Graphic Design Portfolio Strategies
for print and digital media

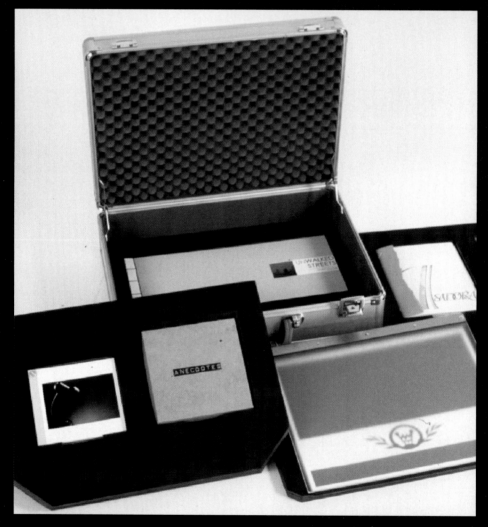

A portfolio with a varied set of materials: The aluminum carrying case has been fitted with several layers of foam board trays, each with carefully cut wells that hold books.
Kyle Everett, Bradley University, Peoria, IL

Graphic Design Portfolio Strategies
for print and digital media

Robert Rowe
Bradley University

Gary Will
Bradley University

Harold Linton
George Mason University

Prentice Hall
Upper Saddle River London Singapore
Toronto Tokyo Sydney Hong Kong Mexico City

Editor in Chief: Sarah Touborg
Editorial Assistant: Carla Worner
Senior Editor: Amber Mackey
Executive Marketing Manager: Wendy Gordon
Senior Managing Editor: Mary Rottino
Project Manager: Jean Lapidus
Senior Art Director: Pat Smythe
Interior & Cover Designer: Ray Cruz
Composition/Full-Service Management: GGS Higher Education Resources/
　A Division of PreMedia Global, Inc.
Senior Production Editor: Kelly Keeler/GGS
Senior Operations Specialist: Brian Mackey
Color Scanning: Cory Skidds
Manager, Rights and Permissions: Zina Arabia
Image Permission Coordinator: Nancy Seise
Printer/Binder: Webcrafters, Inc.
Cover Printer: Coral Graphics

This book was set in 9.5/12 Berkeley Book.

Library of Congress Cataloging-in-Publication Data
Rowe, Robert
　Graphic design portfolio strategies for print and digital media/by Robert Rowe, Gary Will, and Harold
Linton.— 1st ed.
　　p. cm.
　Includes bibliographical references and index.
　ISBN 978-0-13-614031-3 (pbk. : alk. paper) 1. Art portfolios—Design. 2. Design services—Marketing.
3. Graphic arts—Vocational guidance. 4. Multimedia systems—Vocational guidance. I. Will, Gary, 1963-
II. Linton, Harold. III. Title.
　NC1001.R68 2008
　741.6068'8—dc22

2008030471

10 9 8 7 6 5 4 3 2 1

Prentice Hall
is an imprint of

www.pearsonhighered.com

ISBN 10:　 0-13-614031-9
ISBN 13: 978-013-614031-3

Dedication

*"To all the students, our own and from around the country,
without whose beautifully creative contributions this book wouldn't exist.
And to all those professionals, colleagues, and former students who
generously shared their wisdom and experience."*

STAPLE DIAGRAM
RILEY TRIGGS
FALL 2006

1

REFLEXIVE EDITING DEVICES
DAVID SHIELDS
FALL 2006

2

RACTALLY DIMENSIONAL WALLS
MICHELLE BAYER
FALL 2006

3

DINAR HIJAB
TANISA SHARIF/ DAN OLSEN
SPRING 2007

4

RELATIVE TIME
DAN OLSEN
SPRING 2007

5

ROBIN PEEPLES

Selected works from the 2006–2007
academic year.

A set of five process books, and slip case. Each book is 7.5" x 9.75" varying in
length from 8 to 10 pages. Gray Slipcase, 7.5" x 10" x .625", gray card stock.

Table of Contents

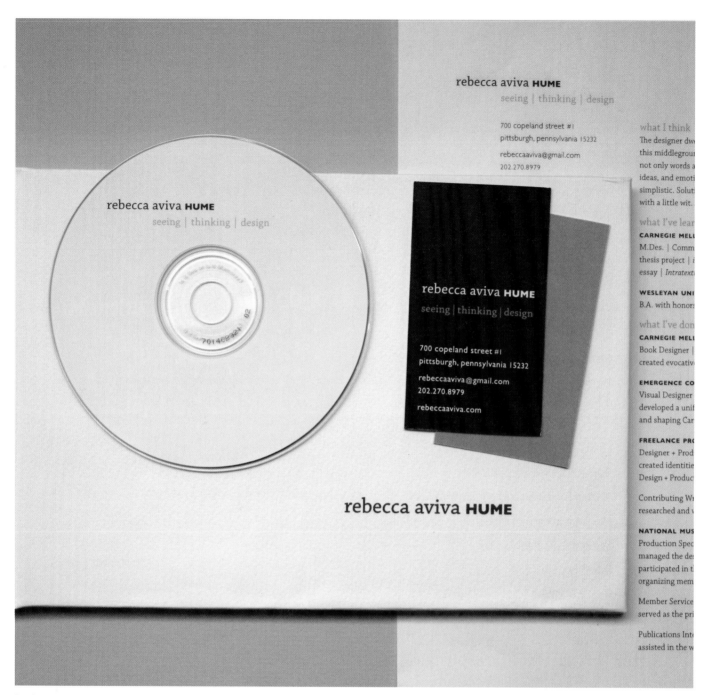

Portfolio book and CD with résumé.
Rebecca Aviva Hume, graduate student, Communication Planning + Information Design, Carnegie Mellon University, Pittsburgh, PA

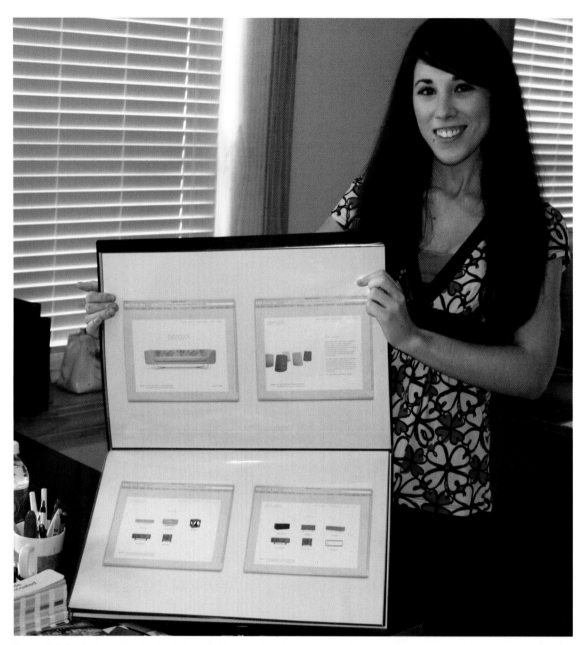

The portfolio book, shown here by the designer, is 33 pages depicting 11 projects. Page size 13" x 19".
Susan Cholewa, Northern Illinois University, DeKalb, IL

Foreword

A portfolio is not just a selection of work. It is a brand. Like any brand, it tells people what to expect from a product. This time, the product is you. The first step in building your brand is finding out what you want to say. Is your work classic, contemporary, or eclectic? Are you fluent in multiple languages (Spanish, English, Korean, Flash ActionScript)? Do you have special abilities that set you apart from other entry-level designers (a literary flair, skill with a camera, or backend Web design experience)? The design of your portfolio should express who you are and what makes your work stand out.

Just as important as *what* you say is *how* you say it. Potential employers or clients reviewing your portfolio will have a keen eye for details—and so must you. Many students and young designers neglect to check their work for typing errors. It's easy to slip into complacency, believing that because *you* can't spell, others can't either. Think again. Take the time to be sure your work is error free, and always use concise, professional language.

Neatness counts, too. If your portfolio is a hand-bound book, this is a great opportunity to showcase your skills in folding, cutting, sewing, gluing, and binding paper. (If you failed Home Ec, consider using an online print-and-bind service instead.) Smudged paper, torn edges, and poorly glued comps send a very bad message about your brand.

Expect your portfolio to change and grow. Keep a clearly labeled archive of all your digital files so that you can update and reformat work as needed. Eliminate outdated projects as your work grows more sophisticated. (That logo for your grandma's grunge band? Maybe it belongs in your scrapbook now, not your portfolio.) Don't be afraid to include "dull" pieces if they speak well of your skills. (That 300-page corporate phone directory that you typeset and corrected during a summer internship could demonstrate your ability to conquer style sheets, databases, large volumes of complex text, and long periods of extreme boredom.)

Your portfolio is a point of conversation. When you land an interview, you will be expected to talk about your work. Dress well. Be concise. Don't mumble. And don't point out all the flaws you see in your work. Never complain, "My teacher didn't like this piece, but she's an old bat," "The client hated it, but he's a jerk," or "My boss told me to take a really long vacation when I popped out this puppy." Design is a team sport, so don't act like a player who won't share the ball.

During an interview, show printed samples or handmade comps for books, brochures, and packages. A portfolio book may highlight just one or two spreads from a multipage document; showing the real thing demonstrates that you can carry off a big project from start to finish. A beautifully bound and printed pamphlet or a detailed identity manual shows off your skills.

Finally, think about how you will say good-bye. A well-designed (and error free) resume as well as a memorable business card are standard leave-behinds. Some designers also create modest souvenirs such as a set of stickers or a rebranded candy bar or tin of mints. If you go this route, keep it small and simple. Treat every interview as a privilege and an opportunity. Even if the firm you've visited doesn't have a position for you, the people you meet there might know of other opportunities, or they might have you in mind when a colleague calls them looking for a fresh hire. Send a thank-you note to follow up, but don't be a pest.

Good luck on the road to building your own brand. This book will set you off in the right direction by showing you high-level examples being created by other young designers and explaining what makes them work. Get out there and have fun. Designing your own career is one of the most important assignments you will ever have.

Ellen Lupton, Director, Graphic Design MFA Program,
Maryland Institute College of Art

An innovative variation on the saddle-stitched single folio format.
Carol Herbert, University of Georgia, Athens, GA

Preface

As I write this preface, I can't help but reflect on my own unique experiences during those final weeks prior to graduating from design school. While many of my fellow students were carefully finalizing their portfolios under the watchful guidance of their instructors, I was left alone to figure things out for myself. You see, two years earlier I had failed to pass the "Sophomore Design Review," and those of us who didn't make the big cut were restricted from taking senior portfolio class. As you might imagine, I was frustrated, and at times, I felt lost when it came to making intelligent decisions regarding the assembly of my portfolio.

Although my story now dates nearly three decades, the real issue wasn't simply what projects would be "kept in" or "edited out" of the final portfolio collection. Rather, it was a small lesson that I learned during this process that ended up mattering most—something that continues to hold me together as a professional today. I quietly ask myself, "Do you really think this is good enough?"

What's missing in many people's understanding of design is the fact that the more challenging the goal, the more frequent and difficult failure becomes. The larger our ambitions, the more dependent we will be on our ability to overcome and learn from our mistakes. Inevitably, it's often through our shortcomings that we discover the real meaning of great design and the real extent of our abilities. But when our own talent for great design finally reveals itself through trial and error, we discover the greatest pathway for creative growth. This is how we measure ourselves, and this is how we become better.

So what do all these anecdotes teach us about preparing our portfolio for the real world? Well, on a fundamental level, the *work* itself is simply one small indicator of who you are. Sure, the aesthetic issues associated with execution matter, but the physical design is really just a tiny window into one's true spirit of creativity. What really matters is a mindset that is focused on care and intelligence. It's your thinking that produces powerful and lasting ideas. For the record, you'll be asked more specific questions about what it took to arrive at a solution, or what motivated you to make a specific type choice or color decision. It's your thinking, and the thought process itself, that tells a far richer story of who you are and what makes your work unique.

In today's world, we quickly become immersed in a host of daily events and everyday challenges. As a result, we're so often caught up in the minutia of work that we barely have time to consider the larger context of design. For many, the only time we'll ever consider the question, "Where do you see yourself in five years?" is during the portfolio interviewing process just after we graduate. Although it's certainly hard to imagine what you'll be doing in five years (let alone five weeks), this particular moment in your career may be the only time you ever ponder this question again. And this speaks to the importance of issues like "do you enjoy what you do?" and "tell me how you think." Keep this in mind as you plan for your career in the larger context. After all, the idea of waking up well into the twilight of our career to find we are unchallenged, uninspired, and unhappy is the last place we want to be. Better that we consider our career from a perspective that reaches far beyond the significance of a collection of artifacts found in our portfolio. Always remember that designers are constantly surrounded by successful and beautiful creations, but we're just as inspired by a life that is personally fulfilling and rich with experiences along the way. Think of the "act of designing" as your life goal, and your portfolio merely a wonderful result of the adventures that happened along the way.

Dana Arnett, Principal
VSA Partners, Inc.
Chicago, Illinois

Portfolio case with original projects.
Sharon Nao, Art Center College, Pasadena, CA.

Introduction

This book has been written for students and professionals who need to create a portfolio to present their professional credentials as they prepare to enter the fields of graphic design and interactive media. A portfolio is essential for seeking employment as a designer, but it is also needed for graduate school admission, obtaining freelance work, or starting your own practice. Employers express a preference for hiring competent and imaginative problem-solvers who can contribute to a creative team. Our goal is to help emerging design professionals develop a strong personal voice, balancing personal goals with demands and expectations in a changing professional environment.

Today's design portfolios are much more than a collection of work done for teachers and clients. Portfolios have moved beyond the traditional black zippered binder to include interactive Websites that blur the line between social and professional networking. Desktop publishing combined with relatively inexpensive high-quality printing has revolutionized portfolios by allowing the designer to re-image and reprint all of his or her work. Now the designer or design student can bring all his or her work together into a carefully laid out sequence of pages. Through a thoughtful and consistent use of materials, the designer can now apply principles of branding to the portfolio presentation. Taking into account the expanding scope of the design profession, changing modes of communication, and a pluralistic and global economy, the expectations for design portfolios have evolved, making it necessary to re-examine the portfolio design process.

For three decades, the coauthors of this book have practiced and taught communication design, environmental design, and fine arts in the United States and abroad. This book brings together their shared experiences along with the opinions and viewpoints of professionals and educators who have commented on portfolio design practices. The portfolios shown in this book are those that instructors and professionals believe to be successful and distinctive. They represent the work of students and recent graduates. While it may be tempting to emulate some of the superficial qualities, it is more important to understand the principle behind the choices.

The material presented in this book will provide the reader with a set of intellectual tools that can be applied across media to "think your way through" to solutions, from the resume and portfolio through to the interview process. By suggesting ways of thinking rather than providing a formula for portfolio design and content, we keep the door open for varieties of personal expression and individual career paths as you cultivate professional opportunities and develop your career. We wish you success on your journey!

Process Books. Four Process Books created by teams of students developing an identity and graphics system for mass transit.
Instructor: Eric Benson, University of Illinois, Urbana–Champaign.

Acknowledgments

A book such as ours would not be possible without the kindness, contributions, and advice of many, including students, faculty, and design professionals. We wish to thank our editor, Amber Mackey, for believing in the usefulness of the book and the role it will serve at a strategic moment during the education and evolution of design students into design professionals.

We are indebted to many and wish to express our gratitude to all those who shared their valuable professional experience on behalf of this project.

Dana Arnett, Principal, VSA Partners, Inc., Chicago, IL;

Ellen Lupton, Director, Graphic Design MFA Program, Maryland Institute College of Art;

R. Kyle Everett, Art Director, Young and Rubicam, Chicago, IL;

Eric Benson, Assistant Professor, University of Illinois, Champaign–Urbana;

George Brown, Professor, Bradley University, Peoria, IL;

Jim Ferolo, Associate Professor, Bradley University, Peoria, IL;

Beth Linn, Associate Professor, Bradley University, Peoria, IL;

Sarah Wert and Sara Levine, Blurb.com;

Chad Udell, Iona Group, Morton, IL;

Steven Merrill, Bradley University, Peoria, IL;

Justin Ahrens, Principal of Rule 29, Geneva, IL;

Skip Dampier, Creative Partner at Tocquigny Advertising, Austin, TX;

Lance Rutter, Creative Director and Principal of Tanagram Partners, Chicago, IL;

Karisma Williams, Games Programmer, Washington State;

Kara Taylor, Vice President, Director of Creative Recruiting, Leo Burnett USA, Chicago, IL;

Meg Pucino, VSA Partners, Chicago, IL;

Neil John Burger, Chicago, IL;

Kevin Reynen, GenGreen, Denver, CO;

Bernardo Gomez, Creative Director, Euro RSCG, Chicago, IL;

Richard Smith, Pentland, London, UK;

David Smit, Pudik Graphics, East Peoria, IL;

Petrula Vrontikis, Art Center College of Design, Pasadena, CA;

Dave Gray, CEO, XPLANE, St. Louis, MO;

Chris Hain, Vice President, Group Creative Director, Ogilvy Action, Chicago, IL;

Blake Ebel, Executive Creative Director, Euro RSCG, Chicago, IL;

Russell Cole, Interactive Designer, Holler, London, UK;

Kate Dawkins, Senior Moving Image Design Director, INTRO, London, UK;

Rick Valicenti, Principal, 3ST, Barrington, IL;

Ewan Ferrier, Creative Director, Enterprise IG, London, UK.

By sharing samples of their work with all of us, our contributors have made a generous gesture of incredible support toward the development of the next generation(s) of graphic designers and multimedia specialists. The authors cannot thank them enough for making room in busy schedules to work with us to make their portfolios available to be appreciated and reviewed by students and professionals. We express our thanks to the following:

Sarah Johnson, Eric Atkins, Joel Raabe, Caspar Lam, Renae Radford, Melissa Crutcher, Catherine Yerger, Dave Werner, Kristen Ley, Rachel Egger, Christopher Morlan, Sharon Nao, Román Alvarado, Val Hebda, Amber Cecil, Tony Knaff, Karisma Williams, John Foust, Jessica Rosenberg, Dong-Wook Rho, Toby Grubb, Sam Copeland, Ho-Mui Wong, Agatha Budys, Brett Tabolt, Steve Petrany, Tom Keenoy, Sarah Clark, Ilana Kohn, Deborah Slutsky, Robin Peeples, Bud Rodecker, Dave Werner, Rade Stjepanovic, Susan Cholewa, Kimberly McMan, Chris Zobac, Mary Rosamond, Mike Livingston, Abigail Peters McMurray, Elizabeth Centalella, Jennifer Mahanay, Katherine Carden, Bilan Nelson, Rachel Shimkus, Vincent P. Basileo, Candice Fong, Susan Dieschborg, Kimberly Melhus, Carol Herbert, Serene Al Srouji, Rebecca Aviva Hume,

Christopher Free, Kristen Ley, Jean-Etson Rominique Paul, Jiminie Ha, Kjell Reigstad, Reece Quiñone, Jonathan Keller, Nick Grygiel, Amy Reiner, Rebecca Lambert; Christopher Berry, Matthew Toler, Nicole Blackburn, Lindsay Landis, Jennifer Oster, Catherine Oshiro, Amanda Knussman, Joshua Newton.

Finally, we are deeply grateful to our families—Linda Rowe, Joanne Will, and Deeni Linton— and our friends and colleagues who provided support and encouragement throughout this project.

The Purpose of Your Portfolio 1

\mathbf{A} portfolio is a precisely constructed vehicle for communication. It is the culmination of years of study and hard work. Your portfolio may include the main portfolio book as well as a Website, résumé, cover letter, business card, leave-behind, and, of course, some sort of case or binder. The reasons for creating a portfolio may differ somewhat, as explained below, but the cumulative effect will be greater if the components all convey a unique style or voice. The process we are describing in this book is one of investigation and inquiry that will assist you in discovering your professional voice.

There will be many times during your career that you will need to present a portfolio, including applications for internships, employment, graduate school, scholarships, fellowships, and design competitions. As with any well-designed piece of communication, it is more likely to succeed if you first set specific goals and identify the target audience. Some preparation in the form of networking and keeping up with professional literature can help you target your search and define your goals. You will find it helpful to think about what you are presenting both from your point of view and from the points of view of the people on the other side of the table. Understanding their needs is essential to your success!

Although there is some commonality among the various visual communication disciplines, each specific area in design also has unique criteria and expectations when it comes to portfolio presentations. It is wise to target your portfolio as precisely as possible to the position you are seeking. Your undergraduate program probably provided a general montage of practical design assignments. You probably have had some exposure to the differences in the design specialties and now, if you

For me, I found that advertising and publishing companies were more drawn to my typesetting projects, books, and high concept and more traditional projects. Other companies like Hallmark, American Greetings, and Cartoon Network were drawn to highly expressive and creative projects such as my toy, calendar, and 3-D projects, which offered a carefree, fun approach as well as diverse color palettes and ideas.

—Sarah Johnson, Ringling College of Art and Design, Sarasota, FL

have not already, you must make some choices as to your intended career path. What follows is a description of several of the most common types of design portfolios. We present you with this information at this point since it may influence the answers to some of your portfolio questions.

Graphic Design Portfolio

There is a wide range of employment opportunities that fall under the category of graphic design. For the most part, these involve planning and producing 2-D or 3-D graphic material for print promotions, editorial design, packaging, or Web distribution. Design studios, brand consultancies, and corporate in-house design divisions all employ graphic designers on staff. A graphic design portfolio should demonstrate strong typography and layout skills, original concept development, and a finely tuned sense of craft and execution. Design firms often specialize in corporate annual reports, information design, exhibitions, and trade show designs. If you are a student, most of the work in your portfolio will be selected from class assignments; therefore, interviewers will be looking for creative solutions and evidence of originality. It is extremely important to be able to adapt your designs to different media, aligning collateral material for print and Web distribution. Spreads from the portfolio of Sarah Johnson shown in Figures 1-1a–f demonstrate ability and attention to detail over a wide range of design challenges from packaging to book design.

Advertising Portfolio

Advertising agencies work with clients in positioning and promoting products and services through a broad spectrum of ever-evolving media. In many advertising agencies, creative directors, whose background may be in design or in other fields such as marketing, coordinate the work of teams that may be comprised of any or all of the following: project managers, producers, account executives, art directors, and copywriters.

Portfolios directed toward advertising, like Kyle Everett's in Figure 1-2a–d, generally include original multi-part campaigns that feature a cycle of ads and promotions across a range of appropriate media. It is important to demonstrate that you can come up with ideas that connect to the target market on emotional as well as intellectual levels. You should be able to succinctly describe the marketing strategy and how you addressed it in your design.

As an advertising creative designer, your stock in trade is your ability to come up with ideas. Many ideas! You want to show that, given the opportunity, you can produce very quickly. For this reason, most advertising concepts originate as sketches on paper. Eric Atkins'

portfolio (Figure 1-3a–b) includes pages of vellum that reflect developmental sketches leading to the final design. A demonstration of fine drawing skills in the portfolio is not as important as showing that you are willing and able to communicate an idea by conversational or casual sketching.

Illustration Portfolio

Illustrators and photographers, for the most part, work on a freelance basis. Illustration skills in specific areas may be of value in architectural rendering, character imaging, or 3-D modeling. Most illustrators gain exposure for their work through an assortment of printed or online creative source books and other listing services. Illustration portfolios typically showcase a combination of published examples or speculative (self-assigned) projects. Illustrators usually strive for recognition in one or two areas of strength, for example political satire, product rendering, or editorial images; and frequently cultivate a recognizable style. Ilana Kohns' figurative illustrations rendered in broad strokes, combining vigorous painting style with subtle color moods and detailed facial features, have appeared in numerous publications, including the cover of *The New York Times*/Week in Review. They can be viewed from her Website that contains a simple thumbnail navigation page and links to contact information (Figure 1-4a–d). She has been a practicing illustrator since graduating from Pratt. Like so many young artists, the site also has links to her friends' sites and an active blog that includes recent illustrations and works in progress. Speaking from her own experience as a working illustrator, she states emphatically, "Websites are the single most important tool for an illustrator working today. Print portfolios are obsolete!"

Interactive Media Portfolio

Interactive media includes design for Websites, games, informational kiosks, and an expanding variety of portable devices. The job listings in interactive media fall generally into one of three categories: designers, developers, and project managers. Project managers oversee the hiring and scheduling of multiple projects. Designers create the components and screen layouts, and developers do the coding that makes it all function; but within these categories are more specific disciplines such as user interface designer, information architect, and interaction designer. For example, a typical job description for a user interface designer may involve screen design for Web or game applications. However, the work may also include mechanical or sound activated means of interaction between computers and humans; e.g., key pads, motion sensors, etc. An information architect usually works closely with software and Web teams but

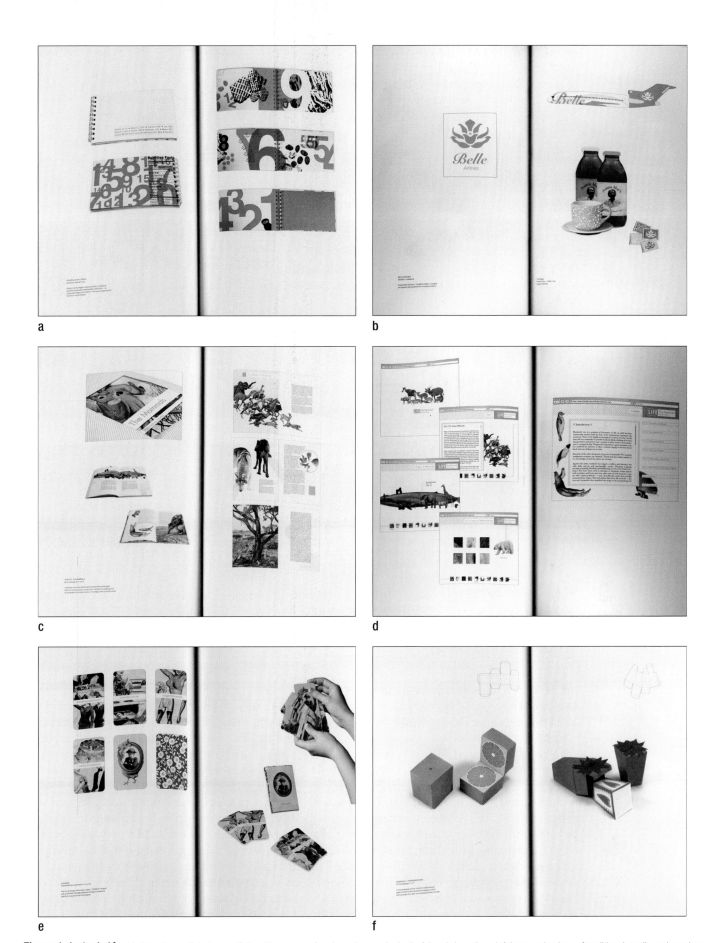

Figure 1-1a to 1-1f Multiple views of design portfolio with a range of projects that are both playful and show thoughtful reexaminations of traditional media and gender stereotypes. 13"×19" **a.** Counting Book: "This was an experimental exercise in visual rhythm." **b.** Belle Airlines identity and collateral "Inspired by the term 'Southern Belle.'" **c.** Redesign for the 1960's TimeLife book *The Mammals.* **d.** Companion interactive Website for the book *The Mammals.* **e.** Old Maid; "This is a redesign of the classic game 'Old Maid,' treated with a retro feel. Through juxtaposed images, I wanted to poke fun at 1950's stereotypes of women." **f.** Grapefruit and strawberry boxes, a fruit packaging project.

Sarah Johnson, Ringling College of Art and Design, Sarasota, FL

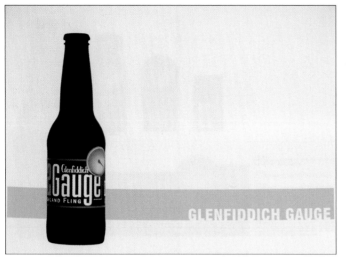

a

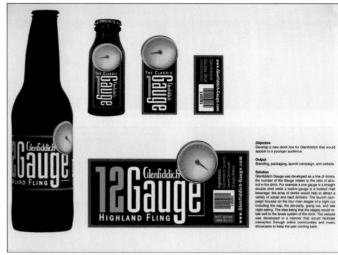

b

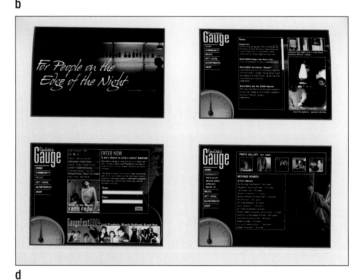

c
d

Figure 1-2a to 1-2d Portfolio book pages showing four spreads depicting an extended media campaign for a new beverage product targeting a young adult market. Initially, a senior student level portfolio aimed at entry level employment, the projects within have been continually refined and replaced as the portfolio gradually transitioned into a collection of work produced within a professional rather than an educational environment.
R. Kyle Everett, Bradley University, Peoria, IL

focus is more on navigation schemes and usability rather than pure design or hard-core coding. New media design disciplines are being created all the time. Descriptions for most of these positions can be found by visiting some of the job listing Websites.

Practitioners in the field of interactive media do most of their communication and networking online. If you are an interactive media designer or developer, you will need a well-designed Website that demonstrates your specific skill set. If you are a developer or producer, you will need to provide links to working interactive sites that demonstrate creative use of the latest strategies in the context of interactive programming. Joel Raabe's Website (Figure 1-5a–b) identifies his occupation as a multimedia producer specializing in audio production. This elegantly functional site serves up rich media in the form of audio and video links as well as a personal Web log.

Graduate School Applications

A portfolio for graduate school admissions differs from one that you would submit to a prospective employer. Although industry is generally market-driven and leans toward practical solutions, graduate programs stress original research and concept exploration. Knowledge of critical writing and new media theory are intimately connected to graduate programs in graphic design and allied disciplines. The main goal for a graduate application portfolio is to demonstrate a body of original thought. In many instances, the role of the portfolio is in support of a clear statement of intent to pursue a particular line of investigation or creative production.

Caspar Lam, an undergraduate at the University of Texas, Austin, created a portfolio of six projects that will be part of his application materials for graduate school

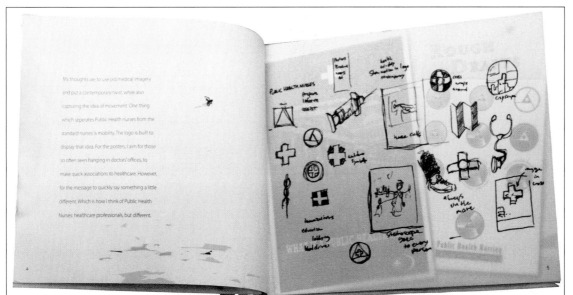

a

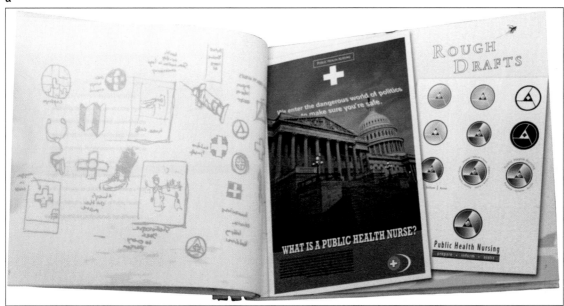

b

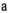

Figure 1-3a and 1-3b A process book including sketches printed on translucent vellum pages over images of the completed series of promotional posters, showing the developmental stages of the project. 7.5" × 9"
Eric Atkins, Bradley University, Peoria, IL

admission (Figure 1-6a–d). Lam's portfolio book contains extensive narrative demonstrating the thought processes behind each project. The projects are for the most part highly conceptual in nature, ranging from experimental narrative to an exploratory mapping of the relative emotional "value" of words based on the assumption that "if words are currency, the force of meaning is value." He depicts sample tables from a book titled *On Currency and Value*. The process information in much of the book takes the form of experimental diagrams and charts that explore unconventional ways of visualizing information.

Renae Radford, who was accepted to the University of Southern California graduate program in digital animation, reports that she submitted a 3-minute demo "reel,"

in the form of a DVD, that included excerpts of all of her best work in animation, multimedia, motion graphics, graphic design, Web design, personal projects, and studio art. "I kept my reel to 3 minutes and no longer since that is the point at which people usually no longer watch your reel. Many people have said to keep reels even shorter, about 1–2 minutes." She directed reviewers to her Website that contained more extensive versions of the projects shown in the short sample clip (Figure 1-7).

Grants, Scholarships, and Competitions

Portfolios for grants, scholarships, and competitions must follow the specific guidelines as to the amount and format of work to be submitted. Most submissions will

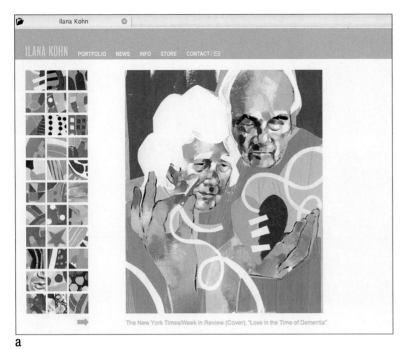

a

Figure 1-4a to 1-4d Website interface and illustration examples: For illustrator Ilana Kohn, graduate of Pratt Institute, Brooklyn, NY, her Website is an important means of gaining exposure for her work. The site shows thumbnails linked to larger versions of the images and contact information. The illustrations shown and the publications they appeared in are: **a.** "Love in the Time of Dementia," *The New York Times*/Week in Review (cover) **b.** "Milwaukee Wine Bars," *MyMidwest* **c.** "Breaking Out of the Comfort Zone," *Colorado Avid Golfer* **d.** "Cell Break," *Seattle Weekly* (cover)

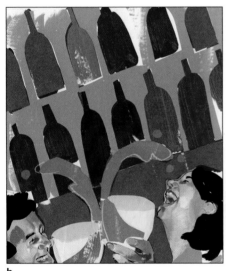

b

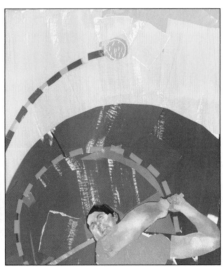

c

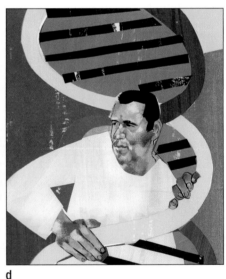

d

require a résumé and artist's statement summarizing the applicant's abilities and creative directions. It is usually helpful to submit these materials in a well-organized binder, with a table of contents and each piece clearly labeled and identified.

Portfolios Through the Eyes of Professionals

What are some of the professional voices in the design field looking for in a new hire, and what do they like and not like to see in portfolios? Their recommendations include good craft skills, facility with type, attention to detail, and concise presentation. Additionally, they are looking for qualities that indicate

the person will be a productive employee and a good colleague; these qualities include such things as positive attitude, an understanding of what motivates people, a subtle intellect, a sense of humor, and a passion for the work.

Justin Ahrens, Principal of Rule 29, a design firm located in the Chicago area, explains what qualities he finds promising in the portfolio of a student he hired. "The student's portfolio was notable for several reasons: great concepts; excellent use of type—for example, the correct size, placement and finesse (kerning, leading, etc.), and the correct font, one that goes with the concept and feel of the piece. It either adds to it or stays out of the way. Also, great imagery, cropped well. Overall

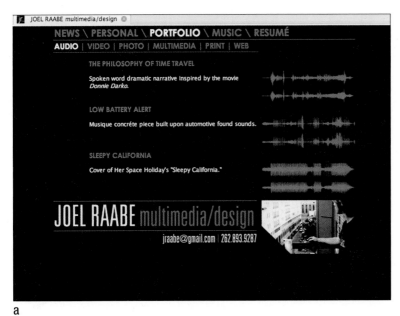

a

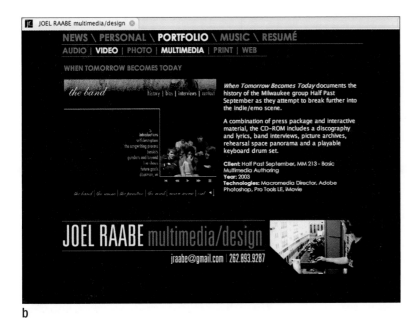

b

Figure 1-5a and 1-5b Multimedia Website for independent audio producer living and working in New York City. His site makes use of open source programming in PHP and MySQL for data integration and ease of editing. It has links to audio, video, and interactive projects.
Joel Raabe, Bradley University, Peoria, IL

composition is clean, with a great use of space that flows well."

There is a lot of design that is imitative and unoriginal. It is easy for a student to appropriate a style or a look from an art annual and apply it to an assignment. Skip Dampier, Creative Partner at Tocquigny Advertising in Austin, Texas, wants to know not only if the designer has talent, but does he or she "know what they are doing and why they are doing it? Show me your work process—the most important thing for me to understand about you is how you think." He offers some additional suggestions: show great original work that has a story, demonstrate marketing and business sense by marketing yourself via some sort of pre-mailer or leave-behind, present diversity in work style and provide evidence of a strong work ethic and a positive attitude.

Lance Rutter, Creative Director and Principal of Tanagram Partners in Chicago, said, "I am looking for someone who is literate, who pays attention to detail, and who has a really positive attitude. I like well-crafted typography. This has to do with attention to detail. This occurs in all forms: craft of the object, the words one chooses, and an understanding of the 'craft of the letter.' To me that means that one understands the rules of spacing—if they use a line of all caps, they consider the figure and ground so that it looks like a line and not a series of dots. I look really critically at the letter the applicants write. I can tell

a

b

c

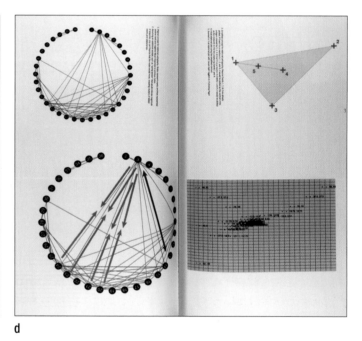

d

Figure 1-6a to 1-6d The visualizations that run through this process-intensive portfolio book depict the conceptual "space" of each project on dimensions that include digital/analog, type/image, and methodology/subject. Eighteen-page book, printed on Mohawk superfine 100 lb. white cover and text stock, side-stitched binding, 8.25"×13".

Caspar Lam, University of Texas, Austin

immediately if they understand the physical properties of type."

Kyle Everett, currently an art director with the advertising agency Young and Rubicam in Chicago, sees a portfolio as an on-going process that continues to develop after graduation. The portfolio that works for a recent graduate is not necessarily the best for advancing an already active career. As career goals become more refined and specific, so should the portfolio. As Kyle puts it:

"One of the things I've learned is that you should present yourself for the job you want. My old portfolio focused solely on my design work, with short blurbs about each project.

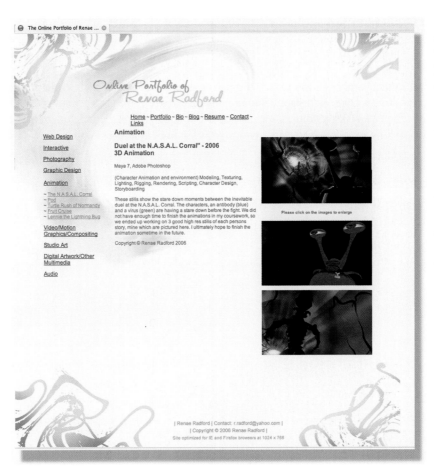

Figure 1-7
Applications to graduate school often require a short demonstration video. This Website contains links to current and past projects, including more complete versions of video and interactive projects. The Website was referenced as part of her application to graduate school. It has a link to an ongoing blog that traces her artistic and personal development over several years.
Renae Radford, animator and digital artist, MFA program, University of Southern California, Los Angeles, CA

I'm now trying to move beyond a design-focused position and start laying the foundation to move toward a creative director position over the next several years. To do that,

I am gearing my portfolio more around the strategy and thought process that went into each project in order to reinforce my conceptual development skills and understanding of

Creative Director: A Creative Director is a visionary/idea person who often comes from a background as advertising copywriter. They hold the position of inspiring and influencing other creative people and their writing, imaging, design and movement for all advertising media while often producing their own work as well. Decisions on how advertising should be developed and produced are grounded by a seasoned understanding of marketing and strategic planning based on competitive and situational analysis and budget. Creative Directors often work with other fellow ad executives to present the agency's new marketing thinking and executions to their clients and potential new business. In terms of where they are in an organization's structure, they can range from company president to creative department leader. They work directly with copywriters, art directors, photographers, producers, programmers, account executives, production managers and clients.

—Dave Wiggins, Creative Director, Hult Fritz Matuszak, Peoria, IL

integrated marketing, basically showcasing the skills required to move in my desired direction."

In this chapter, we have been comparing some of the different fields of design. Karisma Williams, game developer, passed along some advice for people embarking on a job search in any design discipline, which also has implications not only for short-term success, but also for a successful career in general. She advises people entering the field, "It's important to target the discipline that interests you most." She then advises identifying the specific companies. "Targeting pays off in the end because you end up doing what you are passionate about doing, and thus doing it well."

Portfolio Preparation 2

Preparations for the creation of a portfolio will involve both a thorough review of all your work and some serious consideration of your career goals. This is a journey you do not have to take alone. You can put your work into a format that will enable you to share it with peers, instructors, and professionals and elicit their advice. This process will also help you to see your work more objectively. The goals of this process are to decide what to include in your portfolio and what needs to be done to bring the work up to professional standards. Included in this chapter is practical advice on organizing your files, making a digital slide show to assist in selecting your best work, and developing your professional identity through your portfolio choices. Designing your portfolio is a little like juggling six balls in the air simultaneously. These include making decisions regarding the visuals, text material, layout design, paper selection, printing and binding, and the concept for the organization of the portfolio. The trick is to bring all of these things together in a unified, coherent, and elegant product.

Conducting a Portfolio Audit

Now is the time to inventory all your projects and make a master list of the work that you are considering for inclusion in the portfolio. Your inventory can consist of class assignments, work done for clients or employers, samples of process studies, and journal entries. You may also wish to include relevant bodies of artwork such as photographs, drawings, and crafts. Although your most recent work may be fresh in your mind, go back and look through old assignments. Projects from foundation classes and early graphic design courses may have bold, graphic impact that can add variety to the sequence of projects in your portfolio (Figure 2-1 and Figure 2-2a–f). No matter what grade was earned on a design project, you now have the opportunity to refine the solution incorporating constructive criticism. While the execution of some of these projects may not be up to your current standards, with a little work they could be excellent portfolio material.

In most cases, you have the right to use work done in internships and employment situations for your own portfolio. Some issues may occur if work was done under a confidentiality agreement, as sometimes is the case with large agency accounts. You may be able to show such work in a personal print portfolio but not post it on a public Website. As with any professional transaction, it is best to make certain at the outset that both parties agree to terms of ownership and use. Most employers will be helpful in promoting your career. Make sure you clearly define authorship and terms under which work was created. Team projects require that you credit all those involved in the design project, and also spell out exactly what your role was in support of the design. For more detailed directions, we

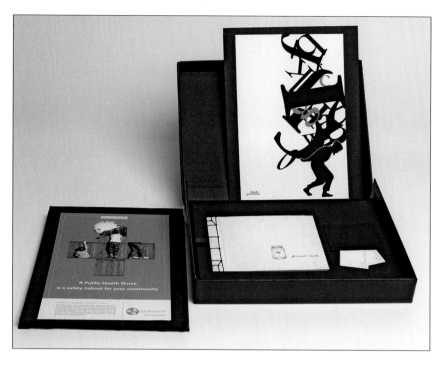

Figure 2-1 A typographic poster 9" × 14" from a fundamental typography class sets a tone for this portfolio demonstrating sensitivity to type and compositional dynamics through effective use of layering, emphasis, and balance. Portfolio: 11.5" × 14.5" black clam-shell portfolio box, 13.5" × 11.75" boards; 1 process book fitted into a recessed well in the bottom of the box.
Eric Atkins, Bradley University, Peoria, IL

recommend you consult the AIGA Website or the Graphic Artists Guild, both of which provide guidelines on copyright issues. (See Sidebar 2-2, page 14.)

Organize the inventory of your work in a manner that seems most appropriate: by date, client, or type of project. Make a chart, table, or spreadsheet, listing each item and its function (branding, publication design, packaging, identity, way-finding, complete campaign, etc.). Indicate whether it needs to be reworked and its likelihood of being included in your portfolio—definite, possible, or slight. Make notes as to the production steps necessary to make it ready for your portfolio, i.e., photography, scanning, image capture, etc. As you progress through the portfolio process, decisions regarding what is to be included and what is to be discarded become easier to make as images are examined in detail and in groups. Most importantly, organize a schedule or timeline for the production of all elements of the portfolio design and construction (Sidebar 2-1).

Organizing Your Files

Well-organized computer files save time locating resources. Many designers are poor at organizing files, especially when they are working on tight deadlines. There is a strong temptation, when a project is completed or presentation made, to stuff all the files into a folder, burn it to a disk and never look back. You may also have multiple versions of a document and not know which is the one with the latest corrections.

As a student you may have created projects on a variety of computers—in labs, at home, or at work—and experienced hard drive crashes, version updates, and other issues that result in files being moved. One problem you may face as you collect your work is missing resources, such things as linked images, and fonts for print projects, Website assets, and online databases. These might be difficult to locate or may even have been deleted. Make use of "package" and "preflight" functions in programs like Adobe InDesign

2.1 Portfolio Production Timeline

The following suggested timeline begins by working backward from a projected deadline. It takes into account materials, planning, execution, and the relationship of key decisions to the final outcome.

1. Select work for portfolio.
2. Research binders and services.
3. Reexamine your work based on size and presentation needs.
4. Create thumbnails.
5. Decide on page sizes and binding and presentation method.
6. Lay out pages.
7. Buy paper. Order binder, schedule printing (if being done by outside service).
8. Print pages (not until you have binder in hand).
9. Assemble book, or get and do any postproduction.
10. Due date: first interview

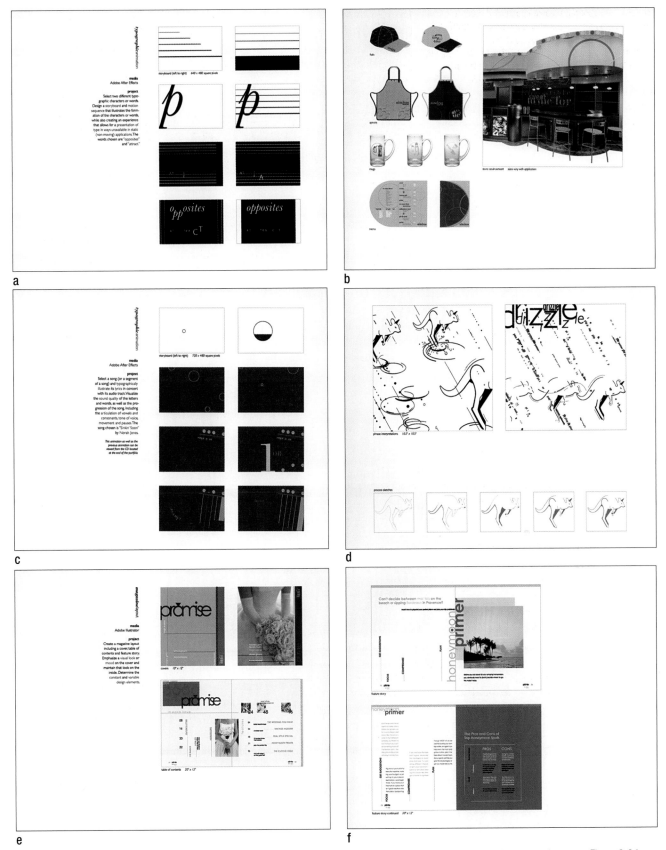

Figure 2-2a to 2-2f Portfolio that combines advanced applied work with projects that show fundamental skills and conceptual process. Figure 2-2d shows the development of a symbol depicting an animal and its use in interpreting a specific phrase, in this case: "In the rain, the kangaroo hopped from one puddle to the next." Figure 2-2c uses a storyboard for an animation project that required animating song lyrics—visualizing the sound quality of the letters, the articulation of vowels and consonants and conveying the rhythm, emphasis and tone of voice. Page size 9" × 12".

Melissa Crutcher, University of Cincinnati, Cincinnati, OH

and QuarkXPress that allow you to bundle together the files and resources associated with a specific project.

Back up your work. As a professional designer, you will find that a good backup system for your digital files is indispensable. A large-capacity external hard drive is a worthwhile investment. Relatively inexpensive—or even free—software is available for automatically saving backups of your files. It is a good idea to develop a consistent and flexible naming system. This will help in locating files now and in the future.

Making Digital Images of Your Work

One of the most useful ways to begin preparing for your portfolio is to make a digital slide presentation of your work. The slide presentation can be created in one of several common applications such as PowerPoint or Keynote (other applications are noted below). The reasons for creating a digital slide presentation of your work at this point in the process is to assist you in determining which projects you will use in your portfolio and which views or spreads of these projects show

them to their best advantage. In order to do this, you will have to make digital images of each project. You can generate these images in several ways: by exporting PDF or JPG images from the original page layout files, by photographing or scanning objects or prints; or by making screen captures. Some projects will have to be depicted through multiple views. These files are not intended as your final portfolio images, but instead are lower-resolution images to help survey and edit your work.

The digital files you are now making may be used to develop an online or digital portfolio later. Since you may want to use these in a Website, name the files in a manner that will avoid problems later on. Don't use spaces, special characters, or symbols and only use periods to separate file extensions. While current html is not case sensitive, certain data-driven Website structures (using php or other databases) may be case sensitive. Either avoid capitalization, or if you do use it, use it in a consistent manner.

You may have a body of work that is not in digital format, such as packaging design, books or folders, and sketchbooks. This work will need to be photographed or scanned. You can scan and organize sketches from your sketchbook, making a more concise narrative of the design process. Catherine Yergers' archive of renderings and process material (Figure 2-3) provides a rich source of potential material for portfolio development. Some projects with multiple parts may be depicted in a composite photograph in which you can show multiple items and give a sense of scale and texture.

Screen captures (also called "frame grabs") can be made from both Macintosh and Windows platforms in order to show interactive projects, Websites, animations, and videos. In Mac OSX, Command-Shift-3 captures the entire screen and Command-Shift-4 allows capture of selected portions of the screen. In Windows, the Print Screen command will allow you to save an image of the current screen.

Still-frame screen captures are a good way to show interactive or motion projects. A series of still frames can serve as a quick sample of what is contained in a time-based project and also can serve as buttons or links on a Web page to the more complete project. Melissa Crutcher uses a series of screen-capture images, in Figure 2-2c, as a storyboard to direct attention to her typographic animation videos. The projects are included on a disk in the back of the portfolio.

Interactive projects can be represented as short Quicktime movies. Software utilities such as SnapzProX from Ambrosia Software, can record a live screen capture demonstrating user interaction with a Website or touch screen navigation. Dave Werner uses motion screen captures in Quicktime format (Figure 2-4) to show scrolling and linking in his interactive projects.

2.2 Copyright and Copywrong

In evaluating work for inclusion in your portfolio, consider the sources of any images you include. It is a common practice, though discouraged by many teachers, for students to download or scan copyrighted images for inclusion in comps.

When it comes to the question of whether to include copyrighted images in your portfolio, the simple and obvious answer is, if you don't have the right to use it, it should not be in your portfolio. This may make for some tough choices, but there are several reasons for it. First, it shows a lack of originality on your part. Rather than relying on a stock photo, be inventive. If you have a design that uses a particular photograph, consider art directing an original photo shoot to obtain a replacement image. It can instantly cool the reception of your work if the art director reviewing it recognizes the image. There is too great a chance that if you found the image, the art director viewing your work has also come across it. It may seem original to you, but may have been seen by the art director multiple times. Second, showing a disregard or ignorance of copyright indicates to a potential employer that you could get him or her into legal trouble.

"Fair use" provides some limited exceptions, allowing the use of works by a person without permission for a purpose that is not injurious; for example, using a work of art in an article about the artist. Show your professionalism and include full credits for work shown; for example, artist, title, date, medium, courtesy of . . .*

Copyright and fair use can be a gray area. But where your portfolio is concerned, venture into those gray areas at risk of damaging the overall impact of your work. Applying the same standard here as with regard to aesthetics, if there is doubt, leave it out.

* Guide to Copyright
AIGA | the professional association for design
Copyright: © AIGA 2007

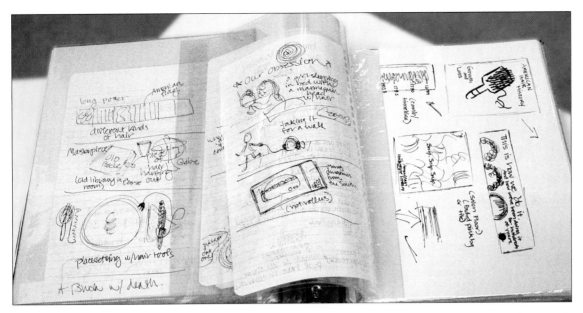

Figure 2-3 Process material, including developmental sketches and multiple iterations collected over the course of several semesters' work. 8.25" × 11".
Catherine Yerger, Mississippi State University, Starkville, MS

"I am not very good or very patient when it comes to photographing my work, and so to solve that problem, I hired a friend who was a photo major at my school to photograph my work. I always art directed each photo shoot, and with her professional equipment and expertise, I got great photos and my time was cut in half!"

—*Sarah Johnson, Ringling College of Art and Design, Sarasota, FL*

Making and Using a Digital Slide Presentation

Once you have made digital images of your work, the next step is to create a digital slide presentation, as shown in Figures 2-5 and 2-6. This will assist you in selecting which pieces of work to include in your portfolio. This can be in PowerPoint format, Apple Keynote, or in Adobe PDF, just to name several of the more common presentation applications. These presentation programs work best if you already have the images scaled and cropped to an appropriate size for screen use (600 × 800 pixels is usually sufficient). Other applications can automatically resize images, save them in a new folder, and generate the slide presentation. Adobe Photoshop CS3 allows you to select various files from one or more folders and export them as a PDF presentation. The PDF format has the advantage of allowing you to zoom in or enlarge the image being viewed.

A Macintosh utility, iPhoto, provides easy access to images, giving some ability to catalog, crop, and rotate. Viewing and organizing them in iPhoto is convenient and has the advantage of not altering the original images. It is not as transportable as other formats but it is good for organizing images on your own computer.

The Adobe Bridge program offers a variety of automated functions, including the export of selected files as Web galleries in HTML, Flash, and other formats. These batch functions can be useful for generating quick presentations, though they may not be easy to edit later. These can be ideal for creating a means of organizing images for use on a CD, DVD, or as a downloadable portfolio. After you have created and edited digital images and produced a slide presentation, you should burn them to a CD or DVD for safekeeping. A personalized label design for the disk, such as that shown in Figure 2-7, will identify it as yours and can coordinate with the rest of your portfolio and résumé package. Attention to detail like this helps establish the impression of you as an organized design professional.

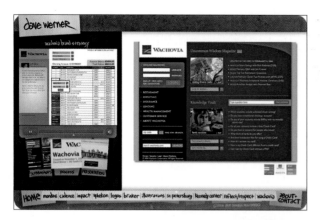
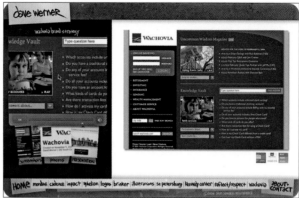
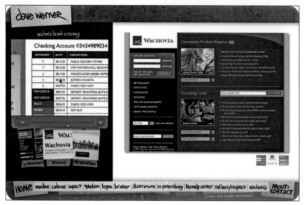

Figure 2-4 Portfolio Website showing user-interface design through Quicktime capture of on-screen interactions and still screen shots.
Dave Werner, Graduate of the Portfolio School in Atlanta, Atlanta, GA

Selecting and Editing

Use a slide presentation as an opportunity to experiment with the sequence of images, creating a logical progression throughout the work. Think carefully about what each piece demonstrates. Do not feel obliged to present your work in a chronological order. Consider the most comprehensive and strongest work as being the first and last pieces in the portfolio, thereby creating the impression of consistent quality from front to back. Perhaps a third strong project can be located in the middle, and the others placed in between these examples. Also, examine each project closely to see what needs to be modified or improved. Determine a work schedule that will afford you enough time to make all the corrections.

At this point, you may need a fresh perspective on your work. In a classroom situation, you can obtain the feedback from instructors and peers. You may not be the most objective judge of your own work. Being too close to your own work may make it harder to see what is unique about it. Someone seeing it with fresh eyes can spot both positive and negative qualities in the work. Each project that is included should be there for a specific reason. Cultivate a relationship with a professional designer in your area. An experienced designer can often discern things in your work that may not be apparent to you. Professionals are very open to talking about career directions, especially if approached in the spirit of inquiry rather than in the context of seeking employment. They can be contacted through a local ad club, AIGA, or professional organizations.

Building a strong network as early as possible will always help you throughout your career. Seek out those who are doing what you want to do and ask for an informational interview. Start letting people know about your goals and ambitions, and you may be surprised. Your network will grow through informational interviews, internships, freelancing, etc.

—Karisma Williams, Games Programmer, THQ's, Washington State.

Figure 2-5 PowerPoint slide presentation created to assist in selecting and sequencing portfolio content.
Eric Atkins, Bradley University, Peoria, IL

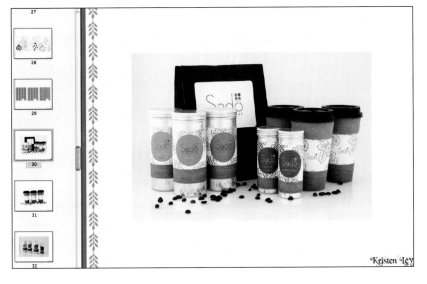

Figure 2-6 Electronic portfolio created in InDesign and Adobe Acrobat. This finished presentation includes subtle branding in the form of distinctive pattern on the left and the name in the lower right of each screen.
Kristen Ley, Mississippi State University, Starkville, MS

Quantity

Three things to keep in mind when reviewing and selecting your work are: Quantity, Quality, and Variety. Quantity is perhaps the easiest. In our survey for this book, most faculty and professional designers expressed the opinion that somewhere between 8 and 12 pieces of work are sufficient. Selecting fewer pieces allows the really strong work to stand out. For example, Rachel Egger's tightly edited portfolio book in Figure 2-8a–f focuses attention on a few well-represented designs. The

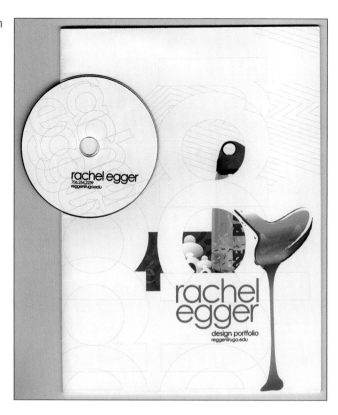

Figure 2-7 Portfolio cover and disk with label, both using similar graphic design vocabulary consisting of type selection, space, color, and line quality.
Rachel Egger, University of Georgia, Athens, GA

format is designed primarily to be mailed ahead or as a drop-off portfolio. It shows just enough work to invite interest and hopefully elicit a callback.

Avoid the trap of including work for sentimental reasons, or, worse yet, because you worked so hard on it. The amount of time and effort you expended or the degree of difficulty are in themselves not an indicator of quality. Sometimes the best work seems effortless, and more effort will not improve a weak or flawed concept. To quote Kara Taylor, VP, Director of Creative Recruiting, Leo Burnett USA, "You can't polish a turd." Letting go is hard to do. While a project that has a really sound concept can be improved by reworking, some projects are doomed to mediocrity. It is better to just let them go. In these matters, an experienced advisor can help you judge whether the idea is worth reworking or whether it should be scrapped.

Time is of paramount importance in any portfolio presentation. It is not uncommon for a design firm to receive two to three portfolios a day, and if they actually advertise a position, the number of applicants can be several hundred. So portfolios get looked at very quickly. Things that arrest the eye may get a longer look. At the end of the day after you have left, if the person with whom you interviewed can recall one piece of your work, you are lucky. If that person remembers that piece of work as one of the high points of his or her day, you are well on your way to landing a job!

Quality

Quality should be evident in all aspects of the work: This means concept as well as execution. To quote Kara Taylor again, "Make sure all the concepts in your book are solid and unique, based on human truths or insights. Never forget that your ideas must make a connection with the consumer, not just your professors or your peer group." Kristen Ley's concept for self-help cookies, Figure 2-9, titled "Gender Gingers" connects with an audience through real human emotions. The work

At an interview, ask for feedback: You are just beginning your career;
don't pretend you're an expert. People who are serious about hiring you
are looking for energy and growth potential, not perfection.

—*Dave Gray, CEO XPLANE CORP., St Louis, MO*

a

b

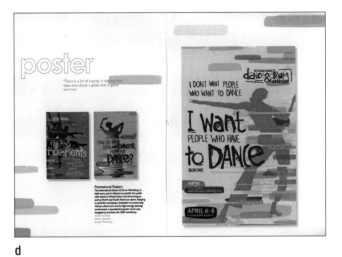

c

d

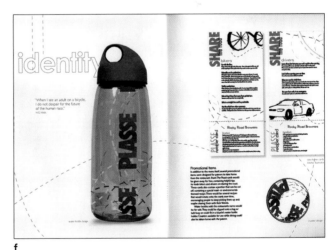

e

f

Figure 2-8a to 2-8f Six spreads from portfolio booklet, saddle-stitched with thread. Printed on Epson Premium Presentation paper, 13" × 9".
Rachel Egger, University of Georgia, Athens, GA

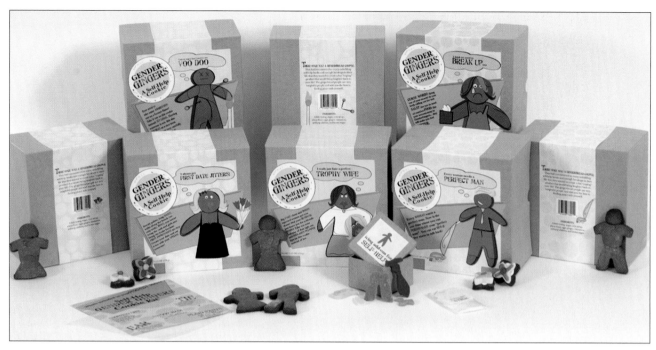

Figure 2-9 "Gender Gingers" Product branding and packaging assignment.
Kristen Ley, Mississippi State University, Starkville, MS

conveys warmth and empathy that is a part of most successful advertising and branding efforts.

Christopher Morlan's portfolio (Figure 2-10a–f) is the culmination of an educational journey of over 10 years that began at the University of Minnesota and included 6 years as Art Director at olcDesign in New York, followed by a stint as Art Director for Maxim PC magazine, and significant freelance work. In 2001, he entered the BFA program at the Academy of Art University in San Francisco. His portfolio reflects the school's concern for the development of a well-integrated narrative. The writing and the design of the pages, as well as the physical properties of the book itself, reflect a consistent aesthetic while revealing the finer qualities of each project over a series of pages. Sometimes with full-page views, sometimes with detail, all projects are beautifully photographed and set off by carefully crafted narrative. Morlan's abilities in "strategic problem solving" come through clearly in the portfolio. Each project shows a solution that directly addresses the communication problem set out in the brief. In his own words: "To me, that is the difference between design and art. Design has an intent—a problem to solve—and it must communicate. The process each designer takes in solving that problem is what really sets them apart. When I'm hiring people, they're being evaluated on their potential to think through all the problems that may come into the studio. Anything you can show in your portfolio that gives a glimpse into your own process is extremely powerful and persuasive."

With regard to quality of execution, there appears to be little disagreement: The work should all be up to professional standards. That means no typographical errors, precision in alignment, consistency in placement of elements; photographs should be professionally composed and printed. The design and placement of explanatory text on the pages of the portfolio must also be handled as carefully as that of any one of your projects. All too often one sees student portfolios in which the descriptions of the work, labels, and captions are full of grammatical errors or reflect careless typographical treatment. What passes for common wisdom (having been repeated often) is that a portfolio is judged on its weakest piece since that indicates the lowest level of your standards.

Work should be reproduced at a size that enables details and readability of type and the quality of images to be appreciated without becoming distorted or lost. It may not be possible to reproduce work at actual size, so one of the more challenging problems in portfolio design is how to show details of your work along with an overview. Your options are to do as Christopher Morlan has done and represent work in multiple views, or to do as Sharon Nao (Figure 2-11) did and assemble a portfolio of work in its original form.

Variety

A third factor in deciding what to include in your portfolio is variety. As in any design situation, place yourself in the position of the reviewer. Pretend you are a designer/art

a

b

c

d

e

f

Figure 2-10a to 2-10f Each of the projects in Morlan's portfolio demonstrates a focus on the essential communication. The production values of the book are of the highest quality. It is 84 pages, containing an introduction, a contents page, 10 projects, 4 pages of logotype designs, credits, and a résumé. 11" × 13.75". Christopher Morlan, Academy of Art University, San Francisco, CA.

director looking at a prospective employee's portfolio. Initially you will flip through it to get an overview. Does the first piece you see arrest your eye? Then does the second spread continue to keep you engaged? On the third page is there something surprising that keeps you looking at the portfolio, or do you look at your watch? If the following pages display some humor, something different, something to suggest that there is more ahead that is of interest, you will continue looking. If not, you will take the measure of what you have seen so far, politely flip through the rest of the pages, and bring the interview to an end. A first impression is hard to dispel.

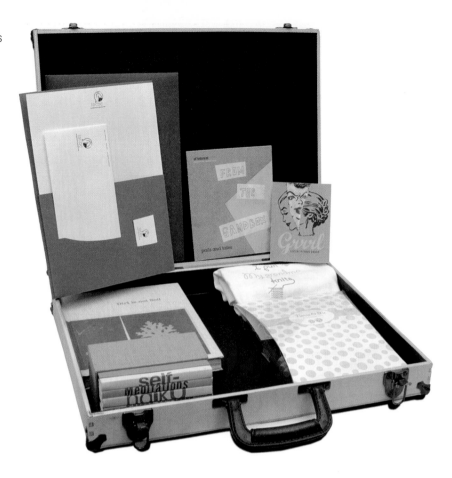

Figure 2-11 Portfolio case with original projects. "Personally my approach has been to show everything as the actual piece so that you can get a true sense of the piece, especially large posters. So far I've gotten great feedback."
Sharon Nao, Art Center College, Pasadena, CA.

Since you are limited to a few pieces of work in your portfolio, you want each piece to show as much as possible. Redundancies are a waste of space and tend to lessen the impact of your portfolio. There are exceptions, but a general rule is to select work that shows specific skills or conceptual solutions. This can apply to techniques, formats, and concepts. One exception to the advice not to show several of the same type of problem seems to be logotypes. Lance Rutter suggests including a page with perhaps four to six logotypes. These same logotypes can also be included in more expanded identity projects elsewhere in your portfolio. Logotypes are such a common assignment that an experienced designer can tell a great deal from how the space, line weight and image semantics are used. Your logotype designs can be a good indicator of how you go about solving visual problems. Kristen Ley (Figure 2-12) includes a board with all the logos from every project in her extensive portfolio.

Consider the range of projects. The value of diversity within your portfolio will vary depending on your objectives. For example, a student applying to graduate school should show a consistent and focused body of work. A few extended projects will

be well received since often in graduate school you will be expected to carry out extended work. In contrast, if you are applying to an advertising agency, especially one that has a diverse client base, variety of work is an advantage. And if you are an illustrator, you want to establish that you have a consistent style and one that can be applied to a range of assignments. This reinforces our premise that there is no one "right" portfolio.

Using the three criteria of quantity, quality, and variety, your selection of work comprises the content of your portfolio. The next step will be to further explore the concept of "voice" as the thread that unifies and brings unique visual dimension to the total package of the work including the enclosing system. Remember, just because you've chosen several projects to be included in the portfolio does not mean they are finished! If your original assignment was to design a poster for an event, you can now consider extending it to the design of tickets, mailers, and other promotional materials. We will now look for ways to take your work to another level. What distinguishing visual characteristics of your work might help unify all of the work and extend the concept of brand and identity to envelope the work and the package?

Figure 2-12 Plate displaying a composite of logotypes. Entire portfolio consisted of 23 boards, allowing for custom selection of projects to take to specific interviews. 23.75" × 17.75".

Kristen Ley, Mississippi State University, Starkville, MS

3 Developing a Cohesive Concept

One goal in designing your portfolio is to distinguish you and your work from the rest of the crowd—to establish your professional voice. Many students go to great lengths to make their portfolios memorable. If you are to be remembered for something, let it be for something that has broad application and appeal—things like impeccable use of white space, succinct phrasing, or immaculate craftsmanship. Most designers, when asked why they hired someone, will cite some specific things that stood out about the portfolio of the successful candidate. As a student, many of the projects in your portfolio will be similar to assignments of other students. What is outstanding about your work? What qualities can you identify that distinguish your design solutions from those of everyone else? Do you go for "better" or "different" or "more intense" or "smarter" or "spot on"—these are all ways of connecting with an assignment. How you answer these questions will be unique to you. Taking a cue from these qualities you want to reinforce, look for ways to establish a "brand identity" throughout your portfolio presentation.

Branding and Identity

The brand is the entire visual and physical experience created by your portfolio and accompanying promotional materials. Brand identity of a portfolio needs to be subtle and never overbearing. It does establish the tone and expectations of what lies within and brings together common threads that run through and unify the work. It is not simply the application of a logo or word mark; rather, it is an overall impression of humor, of literacy, of sensuality, of a love for color, or of meticulous organization. It can be a combination of these. The brand experience of your portfolio represents what is unique about you and is therefore your voice!

Often an idea for the comprehensive design of your portfolio is discovered as you assess your past work and as you become more familiar with the path you wish to take in the future. By finding the points at which your abilities intersect with the demands of the profession, you can create a narrative theme that positions your brand in the market. We will see in the following examples how this is achieved successfully in a variety of ways, and how attributes of visual form can assert your voice throughout the design and production of your portfolio.

Román Alvarado's portfolio presents a distinctive style that involves grids, geometry, and an appreciation for typography. This concern with geometric precision starts with the lettering on the cover and carries all the way through the book showing an underlying structural grid on each page (Figure 3-1a–f). Román says, "My particular work focuses on the process of creating each work by emphasizing the underlying structure of the design elements. The pieces were chosen for their strong geometry and typographic interest, two elements

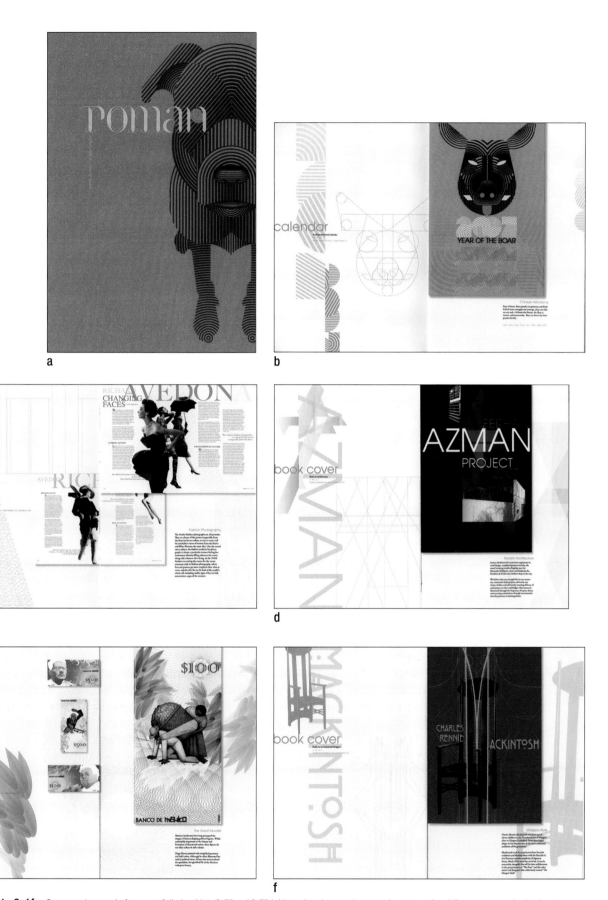

a

b

c

d

e

f

Figure 3-1a to 3-1f Cover and spreads from portfolio booklet. 8.5" × 12.5" inkjet printed on matte coated paper and saddle sewn as a single signature.
Román Alvarado, University of Georgia, Athens, GA

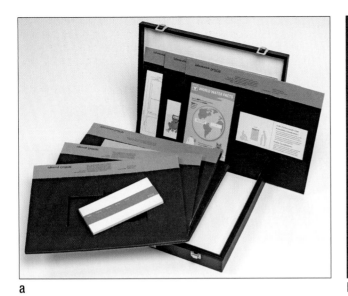
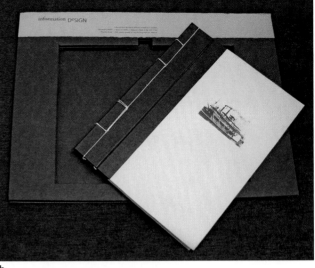

a b

Figure 3-2a and 3-2b Portfolio that makes use of unified theme of texture and color. Plates either have work mounted to them or have pockets that hold folded brochures. A foamboard tray is cut to hold a hand-bound book prepared as a presentation of concept for a museum exhibit.
Val Hebda, Bradley University, Peoria, IL

that are consistent in my design. I have already seen the results from this method of self-promotion. I was called back for an interview and eventually hired based primarily on the work presented in this book."

Val Hebda (Figure 3-2a–b) makes use of a consistent color and texture theme to unify her portfolio book, boards, and résumé. Her interest in three-dimensional design and desire to work with museums and display design was reinforced by the tactile nature of her work. Hand-bound books and the carefully constructed trays that hold individual samples in place reflect a professional level of craft. Now successfully employed as a designer with a museum, she credits her success in part to the attention to these details.

Amber Cecil's portfolio package (Figure 3-3) employs an original illustration in order to establish a personal identity. The portfolio makes use of vellum pages with sketches that overlay the final work, alluding to the technique of cel animation. After working for a time as a junior art director, Cecil followed her interest in animation, which she has pursued in graduate school.

Christopher Morlan (Figure 3-4a–e) creates a unifying theme of storytelling within his portfolio. The tone is set from the first spread onward. The portfolio leads off with a softened photograph of an intriguingly

blank book and the words "Storyline—the most compelling stories are—as of yet—*unwritten.*" This suggests either that the stories are indeed yet to be made, or that the most compelling stories might instead be visual stories. Such carefully crafted use of language is apparent throughout the book. In the introduction it states, "Design always comes down to storytelling." Elements of narrative such as pacing are revealed in the design of the portfolio: The book has a rhythmic flow, with each project beginning with a distinctive opening spread. Words used to elucidate each project in the portfolio are carefully selected to resonate with the message of the design; for example, in the copy for a retail packaging project, the "Swiss Army" brand "in a daring maneuver . . . marches into the skincare space . . ." In an interview with the author, Morlan described the designs as "only coming alive when you play with the words. It's when they're in step with the design that the magic really happens. As much as color, image, or typeface, words are one of the key carriers of meaning the designer works with. They're a vital part of the palette we use." Indeed, the writing reveals a lyrical quality while leaving no doubt that the emphasis is on the message. It is never just a plodding account, but has the snap and sparkle of good advertising copy.

Learn how to write. Designers who can't think beyond a layout will limit their careers.

—Blake Abel, Executive Creative Director, Euro RSCG, Chicago, IL

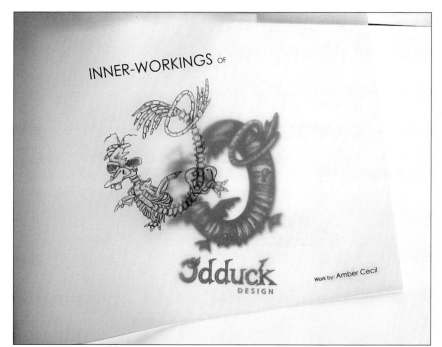

Figure 3-3 Portfolio booklet, with vellum pages. A character illustration is shown with a vellum overlay that reveals the character's skeleton. With the numbers of students who draw characters for games and animation, it takes something a little out of the ordinary to make a presentation stand out. Understanding skeletal structure, even that of cartoon figures, is essential to designing for animation.
Amber Cecil, Bradley University, Peoria, IL

Distinguishing Your Work

Is there something distinctive about your design methodology? Do your design solutions reflect assimilation of design history and established design principles? Or do you venture into experimentation with intriguing forms and qualities of space and composition? Compare the Web portfolio designs of Tony Knaff (Figure 3-5a–b) and Karisma Williams (Figure 3-6a–b). Each made use of a distinctive design vocabulary in order to create a brand identity. Knaff uses Art Nouveau color and motifs in contrast to Williams' design that references a more contemporary vernacular. William's Website has gone though continual development since leaving undergraduate school, reflecting her interests in game design and urban music culture.

It is tempting to design a personal symbol, but a personal symbol that has meaning only to you and the significance of which is not readily apparent does little to demonstrate your abilities at visual communication! If you have to explain it, it is too obtuse. It can also fall into the category of typical design clichés—merging of letters from first and last names, light bulbs, phonetics, to the overused puzzle piece (e.g., I am the missing piece to your jigsaw!). If you do use a symbol, put it to the following tests: Is its meaning or significance clear without explanation; is it intrinsically a good graphic mark demonstrating all the best gestalt qualities; and is it necessary? In the case of a personal identity, the adage "simple is best" works yet again. Your name, simply set and carefully placed, may be all that is needed. Beyond that, use a combination of color, shape, space,

line, and qualities like humor, whimsy, knowledge, or specialized interests like mapping or interactivity to create a brand identity.

A light and conceptual touch, a little whimsical, yet with solid design sensibilities—these are some of the qualities that come across from John Foust's Website. Through a combination of personal and professional work, sketchbooks, and a photoblog, we are left with a smile, not unlike that looking down from the top left corner of the Web page. The face brings his name together with an attitude that captivates with an economy of line. This sense of spot-on humor comes through in several of his design projects—and perhaps is exemplified in the umbrella face—one of the images that cycle on the home page (Figure 3-7a). The professional work is solid, and photographed in a fresh way. For example, rather than show a book as a set of rectangular sample pages, he photographs it propped against a wall at an angle; then in the next view the spreads are laid out on the floor in front of the book (Figure 3-7b–c). The sense of humor and insight is reinforced in a couple of miscellaneous projects. He mailed baseballs to people he respected (designers, mostly) with the request that they sign and return them (Figure 3-7d–e). And he reveals an instinct for understanding and observing human nature by including a short video he made documenting that most people cannot resist looking in an open door (Figure 3-7f). These instincts for how people think and curiosity about how they will react are useful in the field of advertising, which often reaches people through multiple channels of communication.

a

b

c

d

e

Figure 3-4a to 3-4e Title page and four other personal identity pages are dispersed among the 84 pages of the portfolio book and provide evocative glimpses of the design philosophy behind the work, alluding to the connection between literature, reading, and communication skills. Single words or phrases ("informed perspective" or "voice") are superimposed over subtle suggestive backgrounds. Morlan did not make just one book, but two full-sized books and three reduced-sized books. Small books are approximately 60–70 percent of the size of the original. The design was reduced in size, but the type was resized so it would still be readable. Spreads are 22" × 13.75".

Christopher Morlan, Academy of Art University, San Francisco, CA

Can You Tell a Story?

Students frequently ask whether they should include examples of drawings or photographs; this applies to any arts-related skills ranging from bookmaking to sculpture. There is a fairly simple response to that question: *Can you*

use it to tell a story? In visual communication, the message is of paramount importance. People want to see if you can tell a story with your skills, be they photographic skills, typographic skills, or interaction design skills. A self-initiated project can give you an opportunity to go beyond

a

b

Figure 3-5a and 3-5b Flash based portfolio Website that uses colors, patterns, and icons reminiscent of Art Nouveau. Knaff, who now is a senior designer with a Chicago-based company, created this site upon graduation. He now works in identity design, packaging, font development, and animation, fields in which his considerable knowledge of diverse design styles has proved helpful.
Tony Knaff, Bradley University, Peoria, IL

the limitations of art class assignments while exploring or reinforcing your own unique professional identity.

Jessica Rosenberg engaged in several self-assigned photo essays culminating in tightly-organized books showing her photographic skills, but more importantly, demonstrating her ability to tell a story One book has the attention-grabbing title, "Can I Shoot You?" (Figure 3-8a), and the other book has letters embossed

in red plush that read "rsvp" (Figure 3-8b). Both books are shown on her Website. The copy below the images of the book reads, "For about three months, I went to black tie events in Pittsburgh (uninvited) and essentially crashed parties. This book is a compilation of my experiences." As a reader, you are hooked: You want to find out what happened! And the pages that are revealed do not disappoint. The Website opens with a series of

a

b

Figure 3-6a and 3-6b This portfolio Website blends evocative images with sophisticated functional modules, demonstrating both a personal aesthetic and a keen understanding of the rigors of effective interface design. The compact site (that uses Javascript and XHTML) displays her current commercial as well as experimental projects, a blog, and serves up some of her favorite music. Williams is now a game developer working on the west coast.
Karisma Williams, Bradley University, Peoria, IL

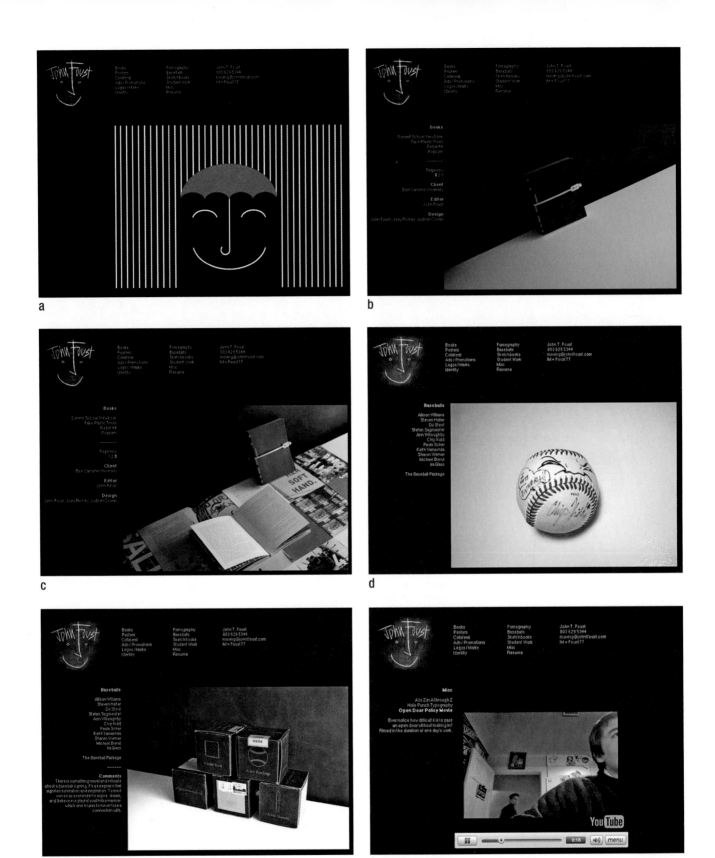

Figure 3-7a to 3-7e John Foust says of his Website, "I get the most comments from the baseballs and sketchbooks. People wonder if the baseballs are mockery or reverence. I am not sure what is most unique, maybe my logo/identity. I was trying to show my personality in the mark and at the same time show respect to clients' work I was privileged to be part of." **a.** Home page with one of a set of randomly changing images. **b.** Book: *Rebel 44* **c.** Book: *Rebel 44*, contents displayed spread out. **d.** Baseball signed by Chip Kidd. (Others include Steven Heller, Stefan Sagmeister, Paula Scher, and Michael Bierut.) **e.** Baseballs returned in boxes **f.** Video "Open Door Policy"—an informal observation on human behavior.

John Foust, East Carolina University, Greenville, NC, currently employed with VSA Partners, Chicago, IL

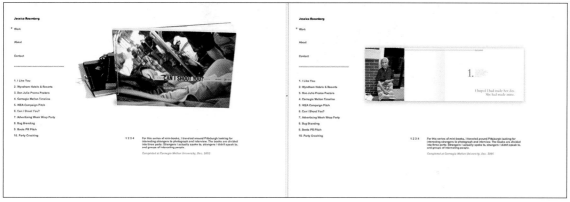

a

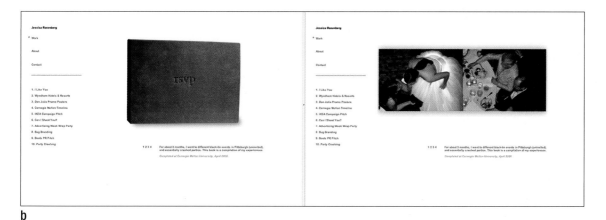

b

Figure 3-8a and 3-8b Portfolio Website. Two photo-essays compiled as books and shown on the Website. Clean interface design with no superfluous graphic elements (or "chrome"). Simple sets. **a.** Photo-essay "Can I Shoot You?" Cover and one of four pages shown on Website. "For this series of minibooks, I traveled around Pittsburgh looking for interesting strangers to photograph and interview." 2005 **b.** Photo-essay "rsvp." Cover and one of four pages shown on Website. 2006.

Jessica Rosenberg, Carnegie Mellon University, Pittsburgh, PA

notebook images, alerting the viewer to look for the unconventional. The inside pages, though, have a clean, efficient navigation which keeps attention on the work.

Dong-Wook Rho (Figure 3-9a–e) combines two separate books into one. The cover on one side of the book has the title *Life* and the other side has the title *Design*. Opened from one direction it reveals a portfolio of approximately 35 pieces of work; opened from the other direction it reveals a personal account of his experiences coming to the United States as an international student. It is written and illustrated with warm humor. Turning the book over, one encounters a more straightforward

portfolio book. At the center of the book, an orange insert indicates where the two meet. The layouts and text of the personal narrative follow many of the best practices of page design, with asymmetrical layout, composite groupings of images, and alternating toned pages; but because the personal and professional sides are separate, one does not detract from the other.

Knowing who you are and what you want can be a powerful force. If you really know what field you want to break into, do some homework, find the best company, find out what they do, and for a really impressive presentation, do a project specifically dedicated to that

Be confident. Be prepared. Know whom you're going to see, know what you want to do—and remember that creative talent is far more important than how many software applications a person knows.

—Kate Dawkins, Intro, London, UK

a

b

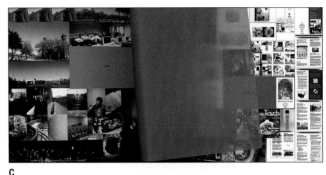

c

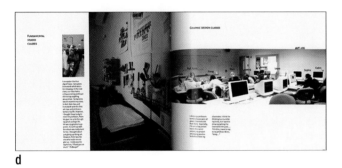

d

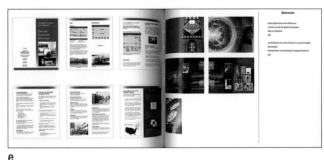

e

Figure 3-9a to 3-9e Cover, inside spreads, and center divider page. This is two books in one. From one side it opens to examples of work from school and an internship with the Smithsonian Institution. From the other side, it recounts a personal history of coming to the United States as an international student. 7" × 10"

Dong-Wook Rho, George Mason University, Fairfax, VA

company's interest. This is not for everyone, but it can have impressive results. Toby Grubb reports that he received an inquiry from Burton Snowboards based on work posted on a public listing site. He created his entire presentation with Burton in mind—portfolio book, Website, boards, and box, with distinctive graphic markings (Figure 3-10). In fact, he created seven mailers with plans to customize all seven for individual companies, but was hired after showing only the second one.

In closing this chapter, we want to encourage you to look at, appreciate, and analyze other people's portfolios, but resist the desire to emulate them. By developing a cohesive concept for your own portfolio that emphasizes the true qualities and individuality of your own work, you increase the chances that you will find a position that is best suited to who you are, both as a person and as a designer.

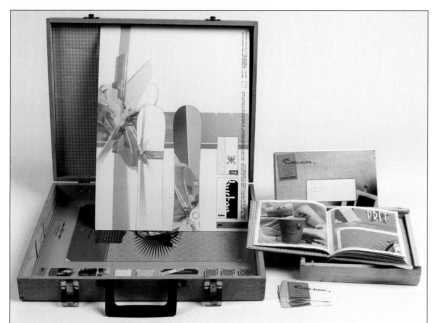

Figure 3-10 A consistent design aesthetic is applied to the portfolio stationery and résumé package, customized to appeal to targeted companies. Grubb has been a designer with Burton Snowboards since graduating in 2004. Package contains mounted boards 10" × 15" in a wooden case, 5" × 7" résumé and portfolio booklet, and wooden box.
Toby Grubb, Bradley University, Peoria, IL

4 Process and Collaboration

In this chapter, we will discuss strategies for demonstrating design process in your portfolio. These will range from showing selections of sketches to creating an entirely separate process book. Many people we have interviewed stated emphatically that portfolios should include some presentation of design process. What is design process? Simply stated, it is the series of steps, or in some cases cycles, that one goes through in arriving at a solution. Although "process" has been written about extensively in design texts—some classics include *Design Thinking* by Paul Rand, the *Designer and His Problems* by Josef Muller-Brockman and *Graphic Design Sources* by Kenneth Hiebert—most sources seem to agree that it generally follows steps of research, iterations, testing, (possible reiterations), and execution. In showing design process, it is not sufficient to simply show any process, but that your process was in fact thorough and appropriate. Related to the matter of process is the issue of collaboration and group projects. These require a little special attention in presentation, but can pay off handsomely in the degree of professionalism you project through your portfolio.

Why Show Process in Your Portfolio?

Reasons for wanting to see process, as stated by professionals interviewed for this book, include confirming the authorship of your work, gauging your work ethic, viewing your idea generation process, and assessing your range of knowledge.

Evidence of your process shows the degree of authorship and gives you an opportunity to present yourself as a potentially good colleague. The design annuals are full of stylish examples of designs that can be emulated or outright plagiarized. In reviewing student work it can also be difficult to distinguish how much of the solution came from the student and how much was art directed by the instructor. In the case of group projects, being able to give credit to colleagues while indicating your own contribution reveals something of your ability to fit into a collaborative working environment.

Just how much effort did you put into a project? In a competitive profession like design, sometimes it is the company or individual that goes the extra distance—perhaps conducting surveys, making site visits, or engaging in extra research that wins the account. It reveals whether or not your design solution came from a thorough understanding of the problem.

Another stated reason for wanting to see process is that it reveals how you analyze a problem. Do you have a system to generate a wide range of alternative ideas? In the course of a professional design project, seemingly good ideas are rejected for any number of unforeseen reasons. Is there some depth to your thinking so that if your first idea is not accepted, you have a range of other ideas to fall back on? Lance Rutter, Creative Director with Tanagram says, "I want to know if you are a literate person. If you show a book cover design, I want to

know if you read the book." Are you a well-read, intelligent person who can contribute to the design dialog?

The degree of interest in process will vary among interviewers. Some human resources divisions for large firms do not have the time to view extensive process material, but judging from the number of interviewers who say they do want to see process, it would seem wise to have it available to show.

The Design Process Book

One solution to presenting process is to create a separate "process book." This allows for more control over when and how discussion of process is introduced. In a class taught by Eric Benson at the University of Illinois, Urbana-Champaign, students create lively and engaging process books that illustrate the stages of design development (Figure 4-1). Key word lists, research, formal experimentation through hand and computer generated images, and multiple iterations culminate in carefully considered design solutions. This is applied to individual short-term assignments such as a Vivaldi concert poster, Figure 4-2a–f, and to extended group assignments, such as the redesign and rebranding of the city's mass transit system (Figure 4-3a–i).

For the transit project, each team engaged in an immersive study of the subject. Team members rode the buses, interviewed riders, and made extensive photographs, much of which was dutifully recorded in each group's process book. Word lists, thought maps, diagrams, and process explanations were generated in attempts to frame and reframe the problem. The resulting design solutions were well grounded due to this thorough understanding of all aspects of the problem.

Several things are noteworthy about these resulting process books. First, they record a high level of commitment and activity, and second, they reflect a good working relationship. Each member of the group is profiled in the book, and their contributions to the whole project are noted. By first establishing a unified group identity and by picturing the individuals in the context of the process book, it presents the group as a

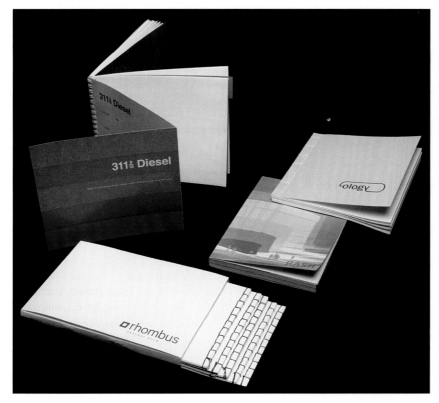

Figure 4-1 Process Books. Four Process Books created by teams of students developing an identity and graphics system for mass transit.
Instructor: Eric Benson, University of Illinois, Urbana–Champaign.

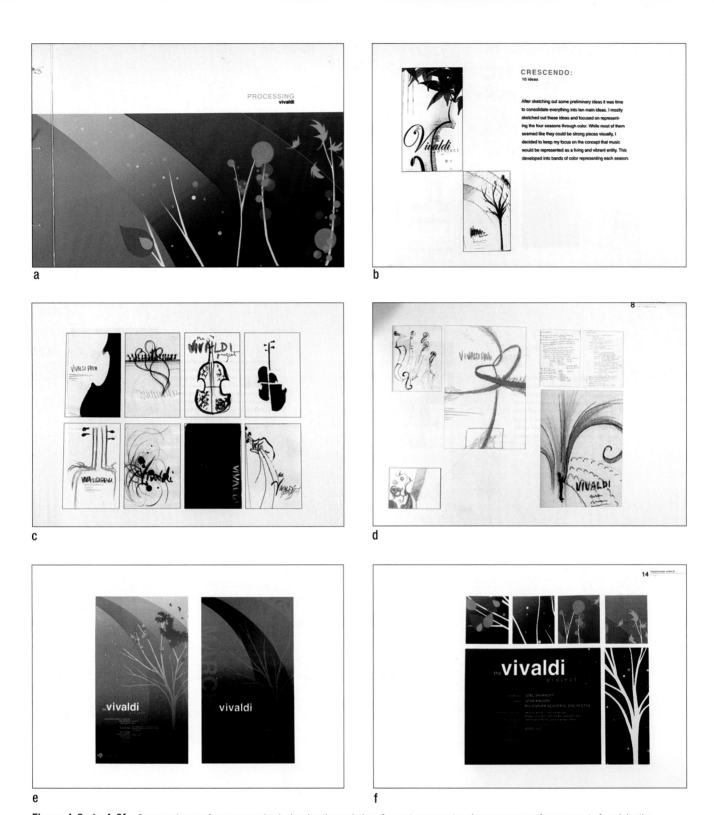

Figure 4-2a to 4-2f Cover and pages from process book showing the evolution of a poster concept and program cover for a concert of work by the composer Vivaldi. The book documents research on the target audience (youth), the music genre, and the multiple iterations. 5.5" x 8.5".
Designer: Katie Clementz; Instructor: Eric Benson, University of Illinois, Urbana–Champaign.

cohesive unit, and the product as something to which all participants contributed. The implied message of the book is that each student participated in a successful and productive group project and so is appreciative of the values of team effort and will be predisposed toward cooperative work in the future. The book and its exuberant tone are thoroughly engaging, even if one does not read it cover to cover.

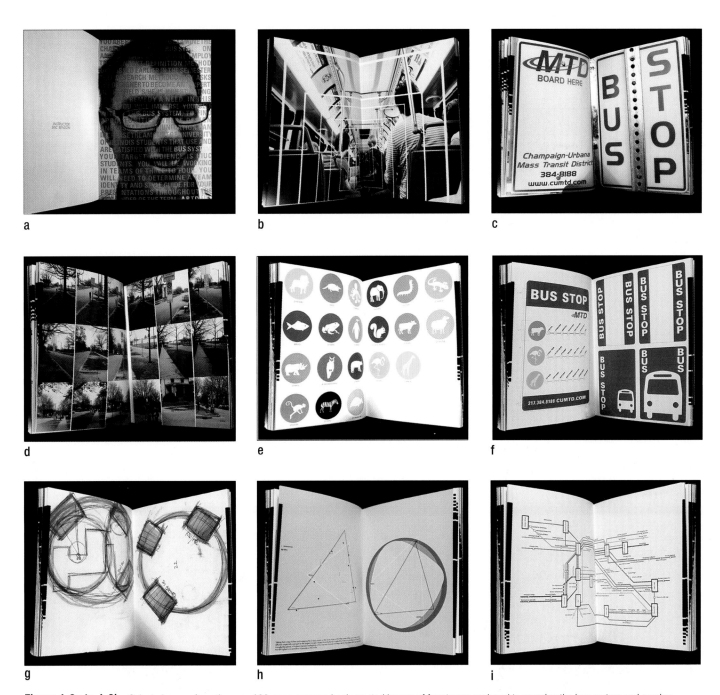

a

b

c

d

e

f

g

h

i

Figure 4-3a to 4-3i Selected pages from the over-100-page process book created by one of four teams assigned to examine the bus system and employ a context-definition method in which the designer becomes an "expert" in the specific subject. Book size: 6" x 8", 188 pages; perfect bound.
Designers: Sam Copeland, Ho-Mui Wong, Agatha Budys, Brett Tabolt; Instructor: Eric Benson, University of Illinois, Urbana–Champaign.

Using Sketches to Show Concept

In many day-to-day professional situations, a concept must be presented and "sold" to a client or creative director before it gets a green light to move forward. Design process in your portfolio demonstrates the ability to present the beginning and intermediate stages of ideation. A person who can engage in a dialog over a piece of paper can save many hours of misdirected work. Sketches are cheap to produce and are a quick way to communicate an idea to members of a creative team. It may take a trained eye to appreciate a rough sketch, but design professionals are used to seeing these. It is an asset to be facile at getting an idea down on paper quickly and expressively. Sketches that look unlabored and appear to be done with confidence are most welcome. It is enough, perhaps, to show that you are not self-conscious about sketching .

If you are showing marker or pencil sketches, they will be easier to understand if you organize them so they are similar in size, shape, proportion, line weight, and detail. It is all right to redraw them. You can copy or trace them over, refining the line quality. Steven Petrany uses sketches to explore concept both for multimedia and for graphic design. The pages in Figure 4-4a–c represent images scanned from various sketchbooks and reassembled in a spiral-bound book. Some designers like to see sketchbooks. If you do show your entire sketchbook, ask yourself, "What does my sketchbook say about me and how I work and think?" What does it say if it is half-empty? What does one crammed full of ideas, intriguing clippings, compulsive renderings say? If you know while you are working on your projects that your sketchbook may be part of your portfolio, you can use it as an integral part of your design process. Without losing too much spontaneity it can be made to be appealing to a professional reviewer.

It is useful to develop a facility at making quick, loose drawings that communicate essential information. Many students express insecurity with regard to their drawing ability. Rapid visualization, like skill in public speaking, can help get your ideas across, and can be developed with a little practice (Sidebar 4-1).

In a time when it is all too easy to appropriate images from the Web, the ability to probe a problem through sketching and experimenting with a variety of materials is especially appreciated. Deborah Slutsky thoroughly analyzes and explores alternatives in creating pages for a book entitled *Einstein's Dream* (Figure 4-5a–i). Her process begins with thumbnails in a sketchbook and extends to experiments with photographic

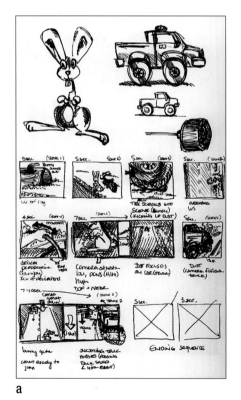
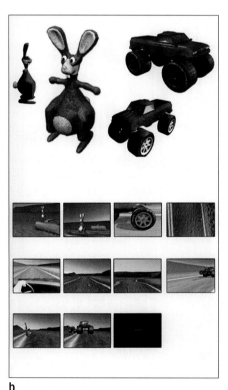
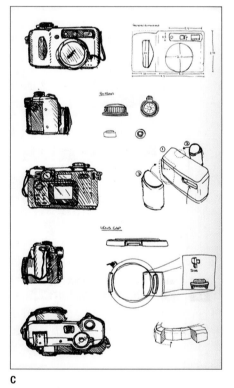

a b c

Figure 4-4a to 4-4c Process book showing developmental sketches for 3-D modeling and animation projects. Images were selected from different sketchbooks and put together in a more logical sequence.
Steve Petrany, Bradley University, Peoria, IL

images, finally arriving at the use of out-of-focus crumpled paper to indicate snowy mountains. In a time when it is all too easy to download images from the Web, this type of unique and personal solution is especially appreciated.

Extensive process presentations are appropriate in portfolios for graduate admissions. These often include projects of a highly theoretical nature, and the end product may be something that does not conform to traditional expectations. Since you will be expected in graduate study to work semiautonomously, a well-documented design process is a good indication that you will fare well in many graduate programs.

Robin Peeples of the University of Texas at Austin created a set of five process books, Figure 4-6a–f, each following the same format. They give an introduction, narrative, and examples of the steps leading up to the solution of each problem. These are, like those of Caspar Lam (Figure 1-6), highly conceptual assignments. They have practical communication design value, but do not fit neatly into common commercial categories.

Showing Process Online: Websites and Blogs

There seems to be a current trend among designers' and developers' Websites toward more newsy, multifunctional formats that include Web logs, the latest "Twitter" updates, and lengthy process galleries featuring work in progress. The ease of using online posting services such as Flickr to show the development of projects or related creative activity provides a new way to demonstrate design process as part of your online portfolio presence. Bud Rodecker, contacted at Thirst in Chicago, where he was employed as an intern following graduation, described how at the end of his senior year, he embarked upon an ambitious program of daily design journal postings on his Website. With a hint of irony, he wrote at the beginning of the blog, "Because I don't have enough to do already, I decided to start a new self-initiated project. I am doing three designs a day, with a time limit of 30 minutes each. They can be anything I am thinking about. With one firm guideline—'Play'." The work shown in Figure 4-7 on page 42 is experimental, insightful, and humorous. The cumulative effect of this project, which extended over several months, demonstrates that Rodecker is committed to design; that he is someone who devotes his spare time to thinking, sketching, and writing about design, even as senior year deadlines draw near.

Dave Werner makes effective use of process notes throughout his portfolio Website (Figure 4-8a–d, page 43). This site uses an array of techniques to demonstrate eleven diverse projects that range from an identity redesign for the Kennedy Center to book illustration. For each project, he has a link to an interactive montage of sketches and other process material along with pop-up captions. In the section in which he shows a sampling of logos, each one appears as a simple image on a clean white field. But when the user rolls over it, a background of sketches and handwritten notes appear (Figure 4-9a–b, page 43). Werner narrates video commentaries on each assignment, combining personal insights on the strategic problems being addressed with contextual images and anecdotes. He establishes a personal voice that reveals his enthusiasm, passion, and hard work.

Documenting process in multimedia projects is critical. Process material in interactive media includes site diagrams for Websites, storyboards for animations, shooting schedules, and production stills for time-based media. Site diagrams are an important stage in developing Websites and often are the first thing presented to clients. Storyboards are to film and animation what site diagrams are to Web work. These sell the idea initially and then serve as vital communication tools between designers, programmers, and other members of the creative or production team.

As an outgrowth of practices in the film industry, it is common now in interactive media projects to have a documentarian as part of the team, whose job it is to make photographs, conduct interviews, and assemble a production document (Figure 4-10a–c, page 44). In the entertainment industry, this "process" material often appears as extras on DVDs, in liner notes, or as documentary short

a

b

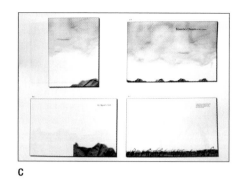
c

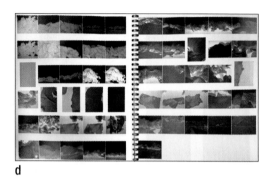
d

e

f

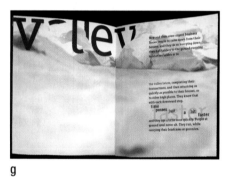
g

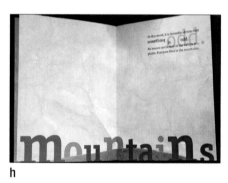
h

Figure 4-5a to 4-5i Process book and final spreads for experimental typographic book, *Einstein's Dream*. The process begins with word lists and pencil sketches and proceeds to thumbnails of page layouts with illustrations and text placement. Experiments with photographs lead to what proves to be the concept for the finished book—photographs, not of actual mountains, but crumpled paper, which, when photographed up close, makes a convincing reference to snow-covered mountains.
Deborah Slutsky, Washington University, St. Louis, MO

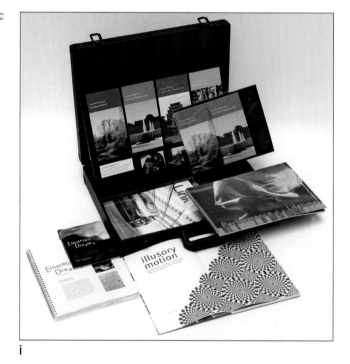
i

a

b

c

d

e

f

Figure 4-6a to 4-6f A set of five process books, and slip case. Each book is 7.5" x 9.75" varying in length from 8 to 10 pages, one containing a CD. Each has a lightweight vellum outer cover, and underneath is a page with a 1.75" round die-cut hole that is aligned over a large numeral indicating the book number. Gray Slipcase, .75" x 10" x .625", gray cover stock.
Robin Peeples, University of Texas, Austin.

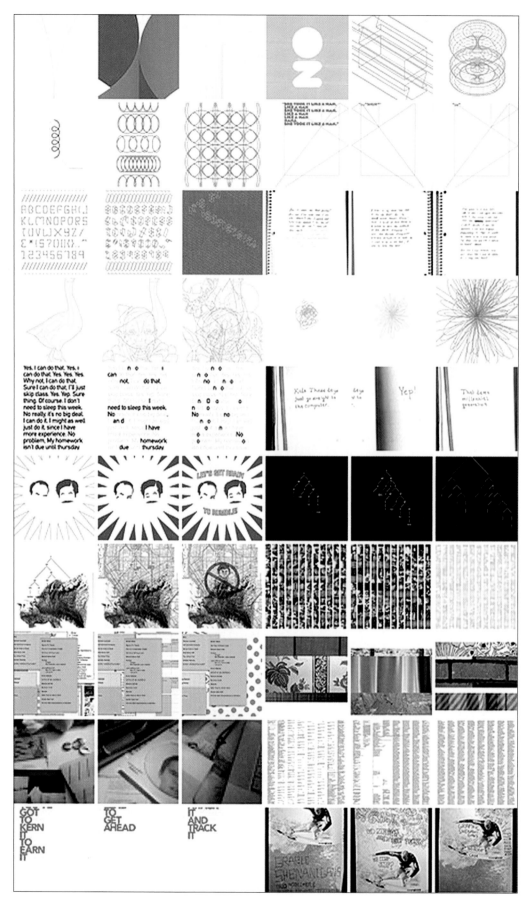

Figure 4-7 Blog sites are a convenient way to post and share concept development. Rodecker's blog, started in the final months of his senior year, shows a disciplined approach to design exploration.
Bud Rodecker, University of Minnesota, Duluth

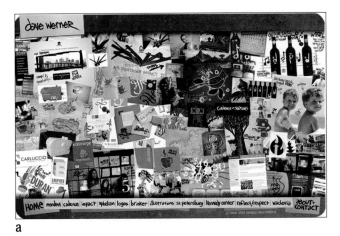

a

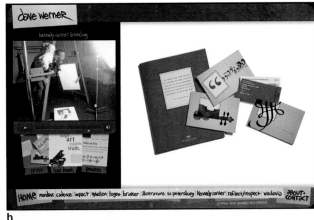

b

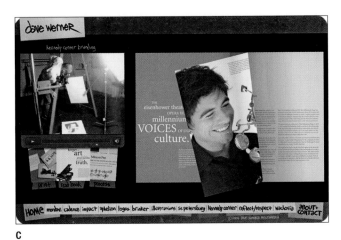

c

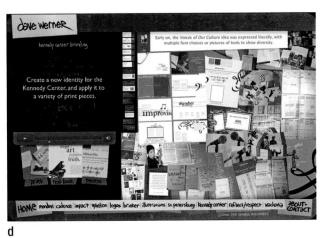

d

Figure 4-8a to 4-8d Richly interactive Website showing Kennedy Center branding project: **a.** Home page shows montage of process material and specific project highlighted on rollover. **b.** Link to print work shows samples of material produced along with a video explaining rationale and design process. **c.** The "read book" link allows the user to turn the pages of the book in the window. **d.** The process link goes to a montage of process material from this project with rollovers that reveal text boxes with additional process notes.

Dave Werner, Design Graduate Student, Portfolio Center, Atlanta, GA

a

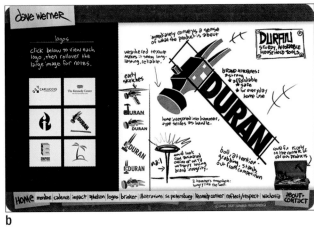

b

Figure 4-9a and 4-9b A compact and interactive way of showing process development: the enlarged logotype image has a white background when it loads, but on rollover reveals a background of process sketches. One of six logotypes in a section of this Web portfolio.

Dave Werner, Design Graduate Student, Portfolio Center, Atlanta, GA

a

b

c

Figure 4-10a to 4-10c Stills from a production documentary on the staging of *The Adding Machine*, a play by Elmer Rice written in 1923. It was adapted by George Brown and Jim Ferolo in 2006 combining live, virtual, and remote performances using high speed Internet2 connections.
Photographs by Scott Cavanah and Duane Zehr for Bradley University, Peoria, IL

films in their own right. Of course, not all projects lend themselves to this, but this may be the best means to show your work on major productions, particularly if they are installations or other time-limited events. One thing to keep in mind is that your audience for this—an interviewer with an appointment schedule to keep—may not have time to watch a lengthy video documentary. Time-lapse, rapid-cut editing, and other ways to compress the time might be very well-received.

Presenting Follow-up

One stage in the design process that is often overlooked is testing or validation. A design can look great on paper, but did it meet the needs for which it was intended? Documenting the success of a project shows a level of maturity and professionalism and an awareness of the challenges of the industry. Things to avoid are letters of appreciation from nonprofit organizations for pro bono work or other instances of praise that may appear biased or unjustified. Examples of significant feedback are documented sales figures, increased attendance, and other quantifiable results.

It can be good for you as a student to enter design competitions. It shows initiative that you have put your work out into a public arena to be judged. Competitions range from the local ad club level to international venues for recognition offered by major magazines, software companies, paper companies, and professional organizations.

I'm probably more interested in how students came to their solutions than the results themselves. This is because, as a junior designer, you become the smallest cog in the team machine, which represents a dramatic departure from being an autonomous, self-empowered student.

—Ewan Ferrier, Creative Director, Enterprise IG, London, UK

Collaborative Projects

As a student or intern, some of your best work may be the result of a group effort. Most professional interactive and print projects are such that they cannot be done by one person, but are the results of teamwork. Depending on the size of the account, it can be as few as two or three people, or, as observed by Kyle Everett, it could be a much larger team including ". . . one or two planners, a project manager, producer, account supervisor and/or account executive, and a creative director. Depending on the size of the project there could be one or more art directors and one or more copywriters; a designer or two; and any specialized art directors for things such as interactive design. If a project is big enough there may be an executive team overseeing it all. In fact, I've just got out of a meeting with twelve people—but that's advertising at a big agency. Certainly other places do stuff smaller and leaner, but almost always in a team of some description."

Do not feel that it in any way diminishes your work if you credit others. As in all professional matters, it is a good policy to be scrupulously honest about your role in the design. Being a cooperative member of a team or a team leader reveals to an interviewer how you work as a member of a team, and that has real implications for your fit in an office environment where teamwork, collaboration, and sharing are essential.

5 Developing the Layout and Sequence

Once you have decided on the content you want to include in the portfolio, the next step is to develop a format and a layout. We will focus the discussion in this chapter on the design of a sequential presentation or book format—something that delivers the main sequence of projects. It can be an actual bound book or a series of presentation boards or "plates" as they are sometimes called. Other items such as samples, booklets, packages, etc., can play a supporting role if needed.

The goal of portfolio layout is simple: Make a positive impression quickly; its impact must be immediate and its quality sustained throughout. The design of the pages, the placement and grouping of images, and the flow from page to page poses some unique challenges. Your choices in layout and typography for the portfolio can be a subtle and powerful way to establish and reinforce a personal identity. What is right for one person may not be right for another. The "right" portfolio is the portfolio that gets you the job in which you will be happy and fulfilled.

Looking Ahead

Decisions regarding layout cannot be made independently from choices of printing and binding which we discuss in Chapter 6. For example, your choice of binder may determine page size, margins, and orienta-

tion. The question, of course, arises whether to design your pages first and then decide on the binding, or whether to decide first what kind of binding method you will use and then design your pages. In actuality, you have to consider both because they are interrelated. We have opted to discuss design of the inside or content first. You can choose to read Chapters Five and Six in either order. In fact, we recommend that you read through both before finalizing the design of your portfolio.

Overall Sequence of Projects

Does the order of your work matter? A portfolio presentation is an experience that you carefully design. Think of it as having a beginning, a middle, and an ending. The two most important pieces in the portfolio are the first and last pieces shown. The first sets the stage, creating the expectation for what follows, and the last piece in the portfolio may be the one that lingers in memory the longest.

Even if your portfolio is a series of plates or boards, you should have a definite sequence in which the artwork is experienced. Thoroughly rehearse sequencing your work in various orders so that you can be confident of the maximum impact possible from the positioning of your best work. Rade Stjepanovic created a portfolio consisting of mounted work on boards, seen

in Figure 5-1. The piece that was on top when the box was opened was an impressive typographic jazz poster. There were many fine pieces that followed, but the closing piece, the one seen last, was also a visually powerful graphic poster.

Contrast is important to sequence. Similar pieces in the portfolio next to each other can diminish the impact of both. It is better to alternate between strong color and muted color, high impact and subtlety. Susan Cholewa makes good choices in sequencing by starting her portfolio with a series of striking lingerie ads (Figure 5-2a–b) that use very sensual design and elegant script type. Cholewa's ads are followed immediately by a series of pages featuring a catalog and Website for a furniture brand (Figure 5-3a–b) that uses minimalist sans serif type with almost architectural precision. Despite the obvious contrast between the two projects, they both reveal design sophistication and close attention to detail.

Another way of looking at creating a sequence of projects in your portfolio is commonly referred to as the "post and rail" approach. Set the strongest work evenly spaced throughout the portfolio beginning with the first project and ending with the last project. Then connect the "posts" with "rails." Consider the value of doing some self-assigned projects that are conceived to complement the main projects in your portfolio. The impression one wishes to convey through this method is that the overall quality of work is consistent from front to back.

Planning the Layout

Start your layout planning by creating a series of thumbnail sketches an inch or two in size that resemble the boards or pages in your book. Depict all the boards or spreads in your portfolio, including optional title page, table of contents, design statement, or section dividers. Working alongside your slide presentation can help you visualize the images as you work (Figure 5-4a–d). Begin by indicating a rough grid or column structure and fill in areas to represent images and text. You will need to follow a grid in laying out your pages, but rather than start with a specific grid, it may be best to roughly place the content in your thumbnails and let the grid develop as you find out how much content, how many images, and how much text you will need to include. In the example shown (Figure 5-4b–d) Kimberly McMan employs a grid to keep consistent intervals and page divisions while varying the size and placement of elements to provide variety from page to page.

Developing a Grid

Working with an underlying grid structure encourages consistency in size and position of page elements, contributing to a coherent design from page to page. The grid is a set of vertical and horizontal divisions usually indicating columns and margins. The grid should provide enough options to achieve an interesting and

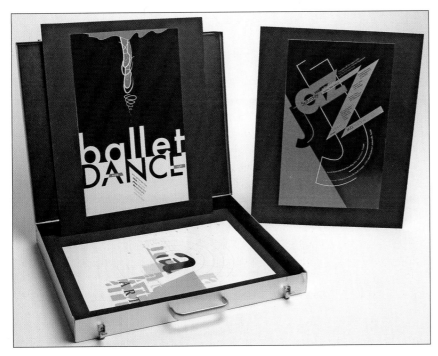

Figure 5-1 Plate portfolio consisting of 16 boards with 10 separate projects. Poster projects mounted on heavyweight black-core mat board 15.875" × 19.5" with labels on the back identifying each project. Aluminum case, 16" × 20" × 2" lined with smooth black paper.
Rade Stjepanovic, Florida Community College, Jacksonville, FL

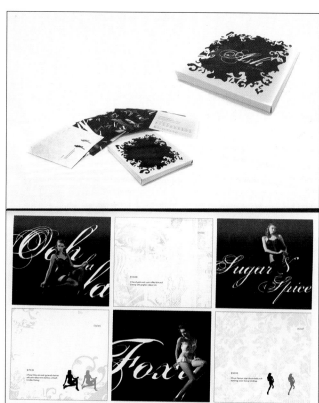

a b

Figure 5-2a and 5-2b Portfolio spreads showing branding for line of lingerie, including packaging, ads, and Website. Page size 12" × 18".
Susan Cholewa, Northern Illinois University, DeKalb, IL

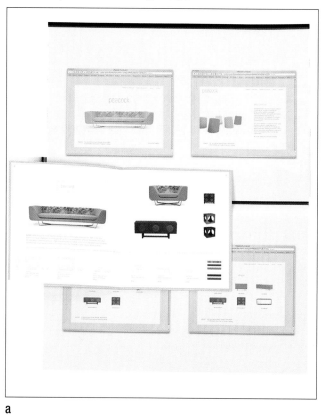

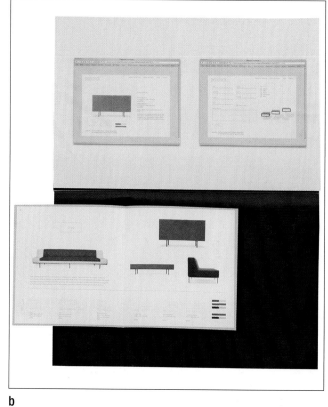

a b

Figure 5-3a and 5-3b Portfolio spread for Peacock Furniture: branding (stationery, three pages of Web screen shots, and carefully crafted catalog extending the themes of color and pattern). Page size 13" × 19".
Susan Cholewa, Northern Illinois University, DeKalb, IL

a

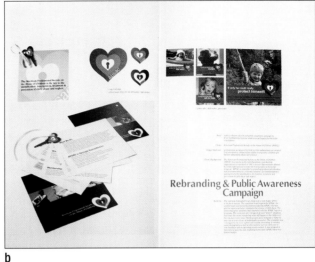

b

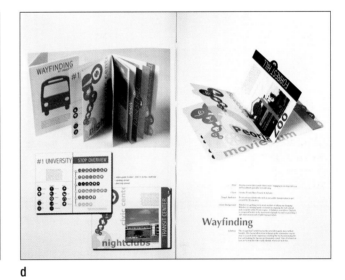

c

d

Figure 5-4a to 5-4d Planning the layout and sequence for the portfolio can begin as a series of thumbnails. Original thumbnail sketches and final spreads from the portfolio showing how consistency and variety can enliven the sequence of pages.
Kimberly McMan, Bradley University, Peoria, IL

varied set of page designs. While usually thought of in terms of editorial design, this same principle applies equally well to plate portfolios or Web pages.

Román Alavarado's book exemplifies the use of a coherent grid-based design. The spread from Alvarado's portfolio booklet, shown here in Figure 5-5, follows the same format as the other pages in Figure 3-1. Each two-page spread in the book is identified by a vertical gray title on the left presented in a typeface that resonates with the design on the page. A large image of the finished project balances the spread on the right. The unique grid on which the specific project was created—in this case, a display on wood joinery techniques—is also represented. The grid in the background communicates a sense of planning and precision in the design and accomplishes several key functions within the spread. First, the grid acts as a foil or background motif against which the exhibit structure is placed. Second, the grid transforms the background into an active versus a passive (or empty) space. And third, the grid acts as a bridge in the composition connecting elements of the page.

Keep in mind as you proceed in designing your own portfolio that you should apply the same standards of design excellence as you would to any magazine or book project. It would be wise to consider the practices of respected editorial designers. In an article in *Step in Design Magazine*, Nancy Bernard wrote in praise of Chris Morlan's outstanding portfolio (Figure 2-10a-f), "Having the display photo cross the gutter and intrude on the text panel is in the best tradition of Modernist

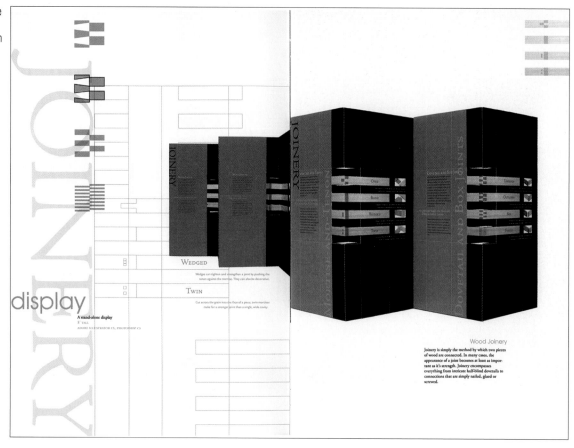

Figure 5-5 The theme of geometric precision starts with the lettering on the cover and carries all the way through this portfolio. Each page shows an underlying structural grid derived from the project being shown. The book is an 8-page portfolio saddle-stitched with thread as a single signature, inkjet printed on matte-coated paper, 8.5" × 12.5".
Román Alvarado, University of Georgia, Athens, GA

design—a gesture that goes back to Alexey Brodovitch at *Harper's Bazaar* in the 1930s.... The rules—big against small, squares against complex shapes, bleeding image against images in gridded layouts, arranged in gentle alternating sequences—never fail."

It is important to indicate clearly where one project stops and a new one begins. Christopher Morlan uses a large numeral (Figure 2-10a-f) in a vertical gray band to indicate each new section. The text that accompanies each project in Morlan's portfolio displays a carefully organized typographic hierarchy. Each opening spread has a main heading, a succinct descriptive passage at an intermediate size, and then a short column of text framing the communication problem and its solution. Chris Zobac, in Figure 5-6a signals the opening page for each new project in his book by a large toned background, ghosted image and project logotype or icon.

Traditional organizing devices such as a running header or footer help the viewer correctly identify projects that extend over multiple pages. In user-centered design terms, this notion of "situational awareness" keeps the viewer oriented within the information system. Keep in mind that portfolios may often be viewed back to front or opened randomly in the middle. There are many other ways to differentiate projects, including tabs, color bars, and icons. You may be so familiar with

the content of your own book that the transitions seem clear to you; but without effective signposts, this may not be clear to someone not as familiar with your work.

Some of the portfolios we encountered that elicited praise from reviewers demonstrated such techniques as full-bleed photographs, grouping of smaller photos into a larger composite, and ensuring that there was a dominant and subordinate side to any two-page spread. Mary Rosamond, who specializes in book design, has much in her portfolio (Figure 5-7) that addresses layering, bridging the gutter, and making use of line and texture to hold spreads together.

Another way to add interest to a book of your work is to use several views of booklets, folders or other materials photographed spread open or standing up (Figure 5-8a–c) . Multiple pages can be shown layered, stepped, or fanned out with some overlap, creating a more engaging and unified shape. This will also allow you to make the image larger than if each separate item is shown in its entirety. Reproductions of rectangular pages can be visually monotonous. Consider photographing sample pages at an angle, some showing detail in close-up with shallow depth of field. For booklets and other three-dimensional printed matter, carefully composed and photographed views can give a very effective representation of the object.

Figure 5-6a Divider pages contain both a short description and associated imagery for each project.
Chris Zobac, Bradley University, Peoria, IL

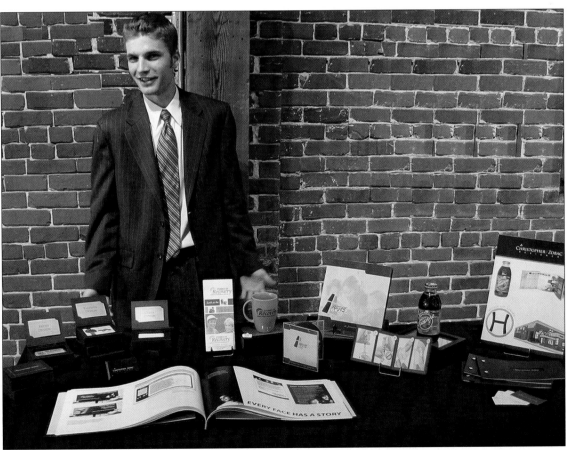

Figure 5-6b Chris Zobac exhibits his portfolio and promotional material at a senior portfolio exhibition, Bradley University.

Figure 5-7 A set of three books on female jazz singers, each hand bound with hard covers and making use of dramatic swaths of color, image, and type. Each book in the series is 40 pages, 7.325" × 10.125". Also shown, *Maximova: A Ballerina's Biography,*7" × 8", hard bound, 16 leaves, one continuous accordion fold glued to back cover.
Mary Rosamond, Washington University, St Louis, MO.

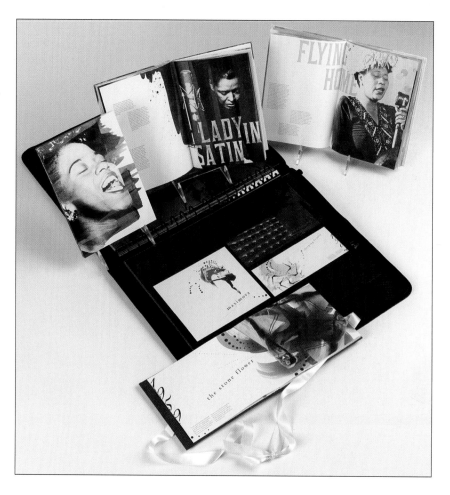

Dealing with the Oversized Piece of Work

Of course, there are times when some inventiveness with the format is called for to display one or two oversized pieces of work. Abigail McMurray in Figure 5-9 overcomes the size limitations of the portfolio box by hinging several of the boards so that they fold out to twice their width. (Note the ribbon pull tab in the front of the box. This is attached to the bottom of the box and helps lift the stack of boards out, reducing the risk of damage to either the boards or the box in handling.) Another example is seen in Katherine Carden's portfolio, Figure 5-10, in which a vertically folded page is bound inside of a book. Another strategy shown in Figure 5-11 is Bilan Nelson's use of a pocket attached to a page to hold a sample. An even larger expanse is created by Rachel Shimkus (Figure 5-12) by using a double gatefold, in which both left and right pages fold out into a double spread.

It is easy to forget that sometimes you can command more attention with careful use of white space than you can with a large image. Carol Herbert (Figure 5-13a–d) displays a wonderful use of interrupted shapes that plays with our gestalt perception that wants to complete the missing areas. These intelligently aligned fragments

activate the negative space on the cover of her book, where letterforms and motifs from various projects transform the white surface into tantalizingly elusive layers.

Continuity in the Plate Portfolio

It would seem that creating a plate portfolio (we will call these "boards") would circumvent the need for a grid. But such is not the case. Even though the boards are not bound in a physical sense, they are bound together conceptually as part of the same presentation. Treat them as you would a series of pages; be sure they are all the same size. Handling a stack of boards is much easier if they are all cut to the same dimensions. Boards can have more than one item on them. Think of the board as a page that can have text boxes and groupings of images.

Several approaches to boards can be employed to keep a sense of design continuity. Valerie Hebda (Figure 3-2) used strips of edging paper printed with project identification and details to lend continuity to the series of plates. In a reference to architectural renderings, the edge of the board can display a table of specifications as well as

a

b

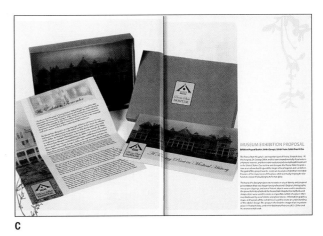

c

Figure 5-8a to 5-8c Publications can be effectively presented by photographing them opened up, giving the sense of the physical dimensions of the book.
a. Mike Livingston, Bradley University, Peoria, IL. b. Nicole Blackburn, Bradley University, Peoria, IL. c. Julie Longenecker, Bradley University, Peoria, IL.

Figure 5-9 Boards are hinged so that they open to show larger projects. The outer box is 13.5" × 13.5" × 3"; covered with light green cloth.
Abigail Peters McMurray, Bradley University, Peoria, IL

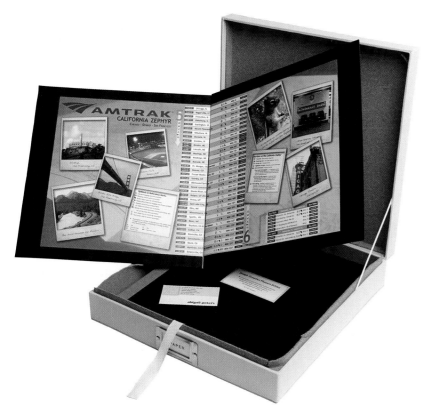

Figure 5-10 An 8.5" × 11.25" horizontal book can still show a large vertical poster design by binding page that folds vertically to present a project that would have lost much of its impact reduced to a smaller size.
Katherine Carden, Bradley University, Peoria, IL

Figure 5-11 Items that have a unique way of folding are sometimes best shown in physical form, in this case in a pocket attached to the portfolio page. 8.5" × 11".
Bilan Nelson, Bradley University, Peoria, IL

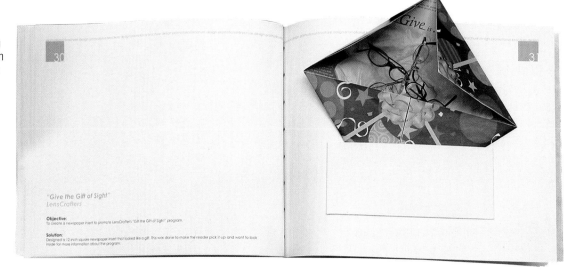

Figure 5-12 Hand-stitched portfolio book, 11" × 14" with gatefold spread that opens out to 41" wide.
Rachel Shimkus, Bradley University, Peoria, IL

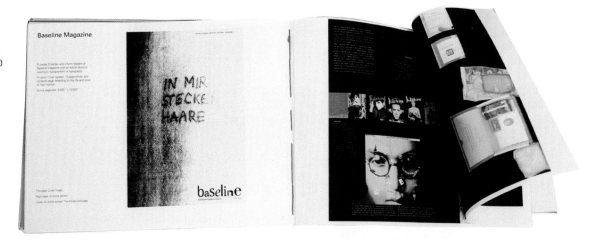

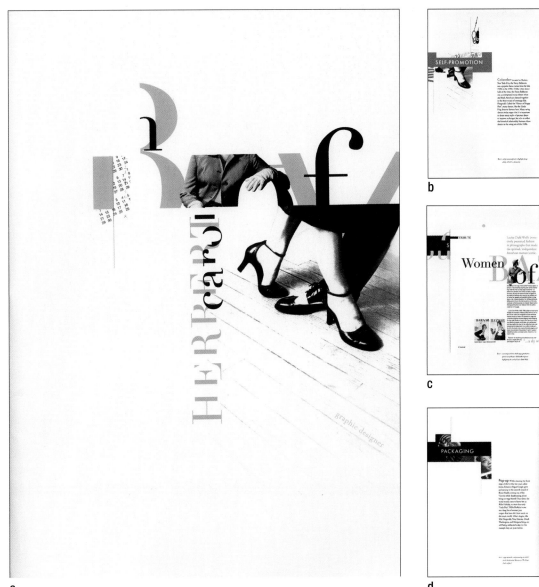

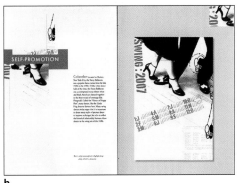

b

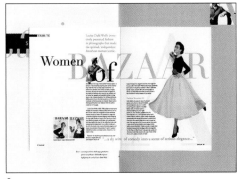

c

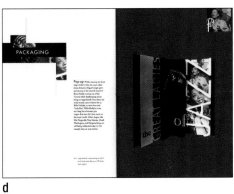

a
d

Figure 5-13a to 5-13d Cover and three spreads from an 8-page mail-out portfolio creates a consistent visual voice by expressive use of white space and layering. 5-13b shows a self-promotional calendar on theme of the Savoy Ballroom; 5-13c shows a spread that pays homage to *Bazaar Magazine* and Louise Dahl-Wolfe; 5-13d shows a pop-up book entitled the "The Great Ladies of Jazz." Page size 13" × 9".
Carol Herbert, University of Georgia, Athens, GA

branded identity. In Hebda's portfolio, the color and texture of the paper edge on the black boards matched that of her résumé and project booklet in the portfolio. Another approach is to design a composite of images, captions, and text blocks as one layout and then print it the full size of your board, mounting it flush with the edges. This allows you to treat each board as a page layout.

The Grid in Web Design

In Web design, employing a grid, or a consistent set of intervals across multiple pages is as important as it is in print design (Figure 5-14). It is disconcerting when every time a new page loads, margins shift and titles are in different locations. Vincent P. Basileo constructed a Flash-based Web gallery (Figure 5-15a–b) that uses a subtle hierarchy to navigate through a menu of graphic design, illustration, and T-shirt designs. The muted color, delicate grid lines, and helpful numbers allow the viewer to browse and focus on the work itself. It is a good use of Flash—each image in the site has a preloader that gives the percent of the file as it loads. In planning your Web portfolio, you should make thumbnail sketches just as you would for a print portfolio and go through stages of roughing in content to finalizing a grid.

Writing and editing. Consider how much text you expect to have on each page, and rough out a simple

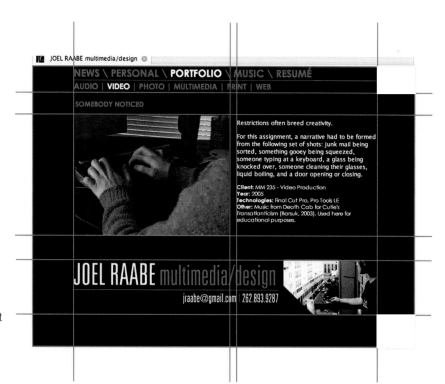

Figure 5-14 A grid is as important in Web design as it is in print design.

Joel Raabe, Bradley University, Peoria, IL

and consistent typographic hierarchy. Although lengthy explanations of work can become tedious and are often skipped by reviewers, carefully crafted copy and an obvious appreciation for the power of words will get noticed. Pay careful attention to typographic hierarchy, using a consistent sequence of head, subhead, body copy, and caption throughout your portfolio. In Figure 5-4b–d, careful balancing of images and explanatory text provide the viewer with context to understand the project in its physical as well as conceptual dimensions. In the final layouts, a succinct description of each project is organized under the headings of "brief,"

a

b

Figure 5-15a and 5-15b This Flash Website shows a precise sense of space and alignment of images, titles, and navigational elements. The magazine design project about youth riots in France employs the visual continuity of a piece of cloth across each of four spreads. This continuity is reinforced by the precise alignment of each page in the sequence.

Vincent P. Basileo, Pratt Institute, Brooklyn, NY

"client," "target audience," "client background," and "solution." Remember that in establishing a hierarchy placement is as important as the size and weight of type.

Rehearsal Portfolio

Once you have established a few different layout schemes through your thumbnail studies, you should test the most interesting concept by creating a full-sized rehearsal portfolio. Rehearsal portfolios are made up of prints or photocopies in position based on your grid, but done in a relatively short time period. They can be created by sketching or by creating paste-ups using printouts and photocopies of your work positioned within your selected grid or column structure to form spreads—all on inexpensive paper. This provides you with a means of testing basic visual relationships of column structure, negative space, text, images, backgrounds, and related details. This is also a chance to get a sense of the size and

format of your pages before investing time and expensive materials.

Once you have established a rehearsal portfolio design you should test the concept by making a full-sized test print. This can be in black and white on inexpensive paper. The size of your portfolio book is one of your more important decisions, as it will affect printing, binding, and overall visual impact. You cannot judge size and readability of printed type by looking at it on a computer monitor. Meg Pucino, from VSA Partners advises, "The work really needs to be readable. Images need to be large enough to see how type is treated and to give a real feel for what the piece looks like." Check the readability of the type, both in the work you are reproducing and any type you are using as caption or explanatory text. Unless the book is intended only as a teaser or leave-behind, it should command attention, and that would argue for something larger than the common 8.5" by 11" format.

6 Form of the Book

The design and craftsmanship of the portfolio determines how the work is experienced. Among the designers we surveyed, there was a distinct appreciation for a well-designed customized presentation. The portfolio concepts surveyed here span a range that includes boxes with portfolio plates, boxes with lift-out trays, hand-sewn books, post-bound books, multiple books, and portfolios that are commercially printed and bound. Portfolio presentations can be one single set of boards, a single book, or a combination of elements. Figure 6-1a–c shows some different types of portfolio presentations. As noted in the beginning of Chapter 5, the decisions of layout and binding methods are interdependent. You can select the binder and let that determine the page size, or you can design your pages first and let that determine the binding. The order of our discussion in this chapter will begin with the outside of the portfolio, starting with the case and progress to printing and binding.

The Outside Case

Most portfolios require some form of protective case. Whether it is dropped off, mailed or whether you present it in person, your portfolio makes an impression as soon as it enters the room. The outer case can be very sleek and modern (Figure 6-2, page 60), or it can be personalized, like this case by Candice Fong (Figure 6-3, page 60). A clamshell box is a traditional enclosing system used to protect books. Susan Dieschborg constructed hers (Figure 6-4, page 61) with a foldout pocket. The combination of book cloth and paper used to cover the box match the materials used in making the post-bound portfolio booklet contained within. Kyle Everett (Figure 6-1b) uses an aluminum case of the kind usually used for camera equipment; inside is a series of trays fabricated from foam board with recessed areas to hold books or other items in place. The case sets the stage; it creates anticipation for what is within.

It will be helpful to know the dimensions of some standard cases before deciding on your board or binder sizes. The size range of most boxes or cases are keyed to standard sizes of boards and paper. In the U.S., standard sizes include 8.5" × 11", 11" × 14", 14" × 17", 16" × 20". European sizes run A4, A3, and A2, most commonly.

From the perspective of the person viewing the portfolio, an effective presentation system is one that is easy to open and close; it should allow the work to be viewed clearly, and it should provide some context for understanding the work. From the point of view of the person making the portfolio, the criteria include: durability, ease of handling, ease of editing, time and cost factors, ability to direct the viewer's attention, overall impression, and of course, the effective presentation of the work itself. There is no one system that scores high on all these criteria. The choice you make should be based on your

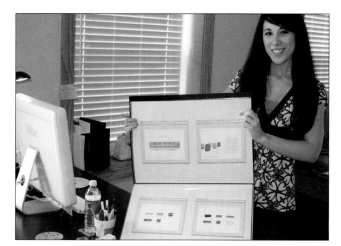

Figure 6-1a The portfolio book, shown here by the designer, is 33 pages depicting 11 projects. Page size 13" × 19".
Susan Cholewa, Northern Illinois University, DeKalb, IL

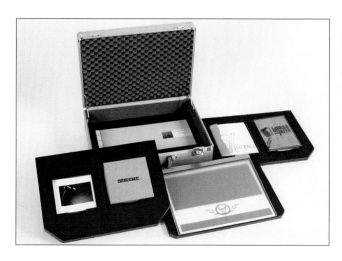

Figure 6-1b A varied set of materials: The aluminum carrying case has been fitted with several layers of foam board trays, each with carefully cut wells that hold books. The main portfolio book is a post-bound binder. The heavy frosted acrylic cover reveals a personal brand identity printed on the first page. Page size 11" × 14".
Kyle Everett, Bradley University, Peoria, IL

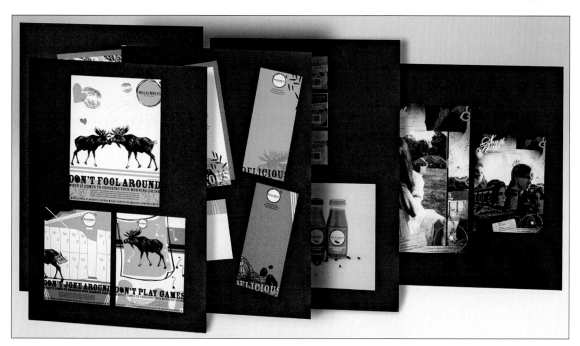

Figure 6-1c This plate portfolio consisting of 23 boards, 18" × 24", displays an extensive range of colorful and creative ideas showcasing skills in illustration and design.
Catherine Yerger, Mississippi State University, Starkville, MS

Figure 6-2 A simple metal portfolio case is versatile and lightweight.

Figure 6-3 Portfolio case personalized with collage material in keeping with student's interest to 3-D design and craft bookbinding.
Candice Fong, Bradley University, Peoria, IL

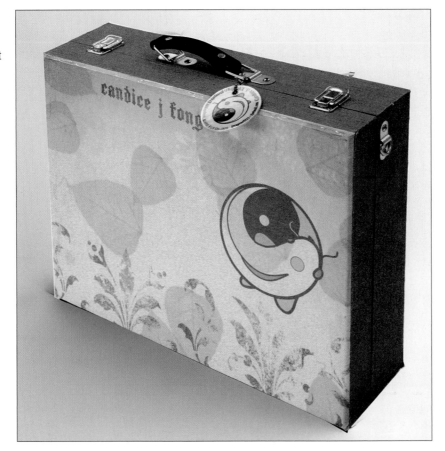

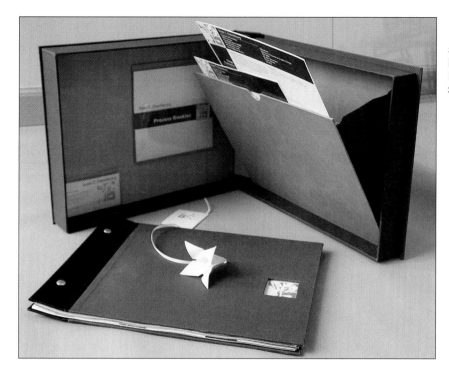

Figure 6-4 Clamshell box with post-bound book and inserts, making use of a cut out square in the cover to reveal some of the image and color on the title page. The color of box liner matches that of her business card and the headlines in the book. Box 9" × 12".
Susan Dieschborg, Bradley University, Peoria, IL

own work and your own aesthetics. From a practical standpoint, anything that is difficult to maneuver in a crowded elevator, revolving door or security checkpoint, or will not fit into the overhead luggage compartment of an airplane should be ruled out.

Plate Portfolios

A plate portfolio or sequence of boards is designed for a group presentation, whereas a book is usually viewed by one or two people. Some schools recommend having both formats. If you have a portfolio that consists of mounted boards, select a box or case that has inside dimensions of height, width, and depth that correspond to your set of boards. Although foam core board is lightweight, its thickness and susceptibility to damage make it impractical. A good quality black-core mat board is preferable. You must mount work to boards so they remain flat. Spray adhesive and rubber cement are quick, but at best temporary. Far superior are the cold-mount methods that usually involve a sheet or roll of transferable adhesive and backing. The adhesive is transferred to the back of the art work, the art is positioned on the board, and it is either run through a small press or securely rubbed down. Heat-set dry mount tissue, traditionally used in photography, is very permanent though the materials and presses are becoming harder to find. Both cold and hot mounting supplies are usually available at art and photography supply outlets and at blueprint and sign-making shops. Plate portfolios are easier to show to a group of people and pieces can be removed or added to the series quickly.

Binders and Binding Methods

Presenting your portfolio as a bound volume of pages allows you to control the sequence of work and creates a more intimate presentation. Consider whether you want to purchase a binder or do some form of custom binding. There are numerous types of presentation or portfolio binders on the market. These range from the conventional, if somewhat dated, black zippered ring binder with acetate pages to some very sleek metal or plastic presentation binders. Custom binding shops also can create very well-crafted hardcover or softcover presentation systems using specific colors and materials.

With some practice, you can create a custom binder yourself using any number of traditional or original techniques. There are many creative advantages to designing a custom binding. With an appropriate design and a good choice of materials, the effect can be quite striking. A word of caution, however; as with any craft, it does require practice. It is not something to attempt on a short deadline. Allow time and materials for several attempts and bear in mind that the effect must look as professional as the work contained inside the portfolio. The hand skills required for custom binding may seem archaic in the age of electronic media, but even large agencies find the need to cut boards, mount prints, and at times make custom binders and presentation items for clients. It also bespeaks an appreciation for paper, ink, folds, and other physical properties that factor into creating printed material.

Post binding. One of the simplest methods of binding a book is to use screw posts. These two-part flat-headed anchors are available in a range of sizes for binding books from .25" up to several inches in thickness (Figure 6-5).

Figure 6-5
Commercially available screw posts.

Figure 6-6a Screw-post binding is a simple mechanical binding that can be done in a variety of ways. It allows you to change pages quickly. The posts can be allowed to show, or, as demonstrated above, they can be hidden by folding the cover back over them. (Always check the grain direction of the paper and score it before folding; paper folds more smoothly if the fold is parallel to the grain but the fold is stronger if it is across the grain.)

Figure 6-6b With screw-post binding or with stab binding, if you are using a rigid cover, you must make a hinge on both the front and back covers so they can fold completely open. Use a strip of book board wide enough to accommodate the screw-posts (about an inch to an inch and a half wide. This will be the spine. Glue a strip of cloth (preferably book cloth) on the spine and the cover, as shown, folding it over to make a neat edge. Be sure to leave about twice the thickness of the board between the spine strip and the cover, as shown, so that the cover can fold back. Then glue another piece of cloth onto the hinge to cover the folded-over edges. Make a hinged front and back cover. Use a drill to make the holes for posts or for sewing.

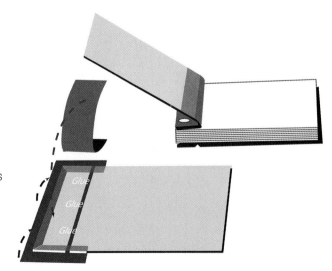

Two or three screw posts are needed to secure the pages together. It requires leaving about an inch-and-a-half margin on each page on the side that will go into the binding. The cover has to either be flexible or hinged so that it can fold open. The posts can remain visible or can be hidden (Figure 6-6a–b).

One of the more famous examples of this binding method, and perhaps the first to be well-documented, is Fortunato Depero's 1927 Futurist work with metal cover and hex-bolts securing the cover. The use of bolts, hinges, and other cabinet hardware has become almost a cliché. The added weight and risk of scratching or damaging other work—or the art director's desk—make such ad hoc adaptations more appealing in theory than in actual practice. Aluminum or brass screw posts, made specifically for fastening pages, are lightweight, have a low profile, and integrate less obtrusively with the book materials.

Jennifer Mahanay, uses two large-format 16" × 22" custom-made post-bound portfolios to show her design and photography (Figure 6-7). The size is effective both for her large-format 16" × 20" color photographs and her graphic design. One book is for photography and one for design; by keeping the two media separate, it gives each an elegant presentation. These books still require a case or cover to transport them and to contain other material that may accompany a presentation. Both books are carried in a black zippered case with an x-shaped restraining strap inside and both a handle and shoulder strap (Figure 6-8a–c, page 64).

Katherine Carden (Figure 6-9, page 65) shows how the post-bound book can become an integral part of the presentation when combined with matching custom box.

Spiral binding or wire binding. One of the least expensive methods of binding is spiral or wire binding. While it can appear unimaginative if not handled well, consider some of its options before dismissing it altogether. Devising a cover that hides the wire can create a more elegant presentation and using two smaller spirals rather than a single continuous one can mitigate the obtrusive line that divides spreads (Figure 6-10, page 65). A slipcase from which the book emerges can help create a more customized presentation. One of the advantages of using wire or spiral binding is that, unlike most of the other methods, the book can lay flat when opened.

Side stitching. An elegant method of binding is side stitching. Figure 6-11 on page 66 shows examples of traditional Japanese binding methods in which the thread or twine that is used makes a visible and attractive pattern. This method allows separate sheets, even sheets of different sizes and paper stocks, to be combined. It is also relatively easy to rebind if contents need to be changed. Pages and cover are made with a wide left margin, the same as for screw-post binding. Holes are drilled through the book block at regular intervals, and a needle and thread are used to sew from hole to hole (Figure 6-12, page 66). The pattern of the thread becomes an aspect of the binding method—some can be very elaborate. This binding method is often suited to textured or tactile materials. Caspar Lam's book in chapter one (Figure 1-6) is side-stitched.

Saddle-stitched binding. Binding can also be done by folding multiple pages together and sewing or stapling down the spine (Figure 6-13, page 67). This is

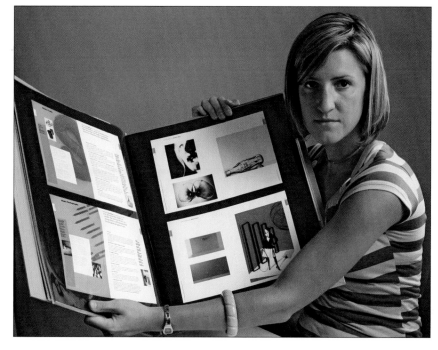

Figure 6-7 Graphic design portfolio.
Jennifer Mahanay, University of Illinois, Urbana–Champaign

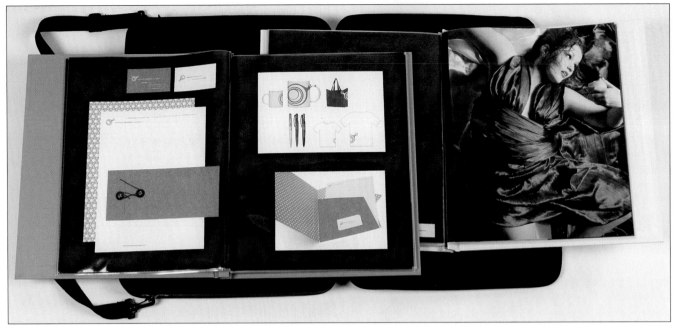

a

b

c

Figure 6-8a to 6-8c This custom made set of binders holds plastic-sleeved sheets. The covers are foil stamped simply with the name of the designer. The two-book format gives equal emphasis to graphic design and photography and is large enough to accommodate composites of printed material at full size as well as show full 16" × 20" color photographs. 16" × 22". **a.** Spreads from design portfolio and photography portfolios. **b.** Carrying case for portfolio books. **c.** Detail of binding.

Jennifer Mahanay, University of Illinois, Urbana–Champaign

also called saddle-stitching. This method was used by Carol Herbert to create a soft-cover portfolio suitable for mailing. (Figure 6-14, page 67).

Some people choose to make individual books for specific projects. This allows the project to be considered in its own context. Even within a larger portfolio, it maintains its integrity. Robin Peebles (Figure 4-6) created a slipcase to hold five project booklets, each giving a detailed description of an individual project.

Adhesive binding. This includes "perfect" binding, which can be done fairly inexpensively by a commercial shop. Perfect binding is better suited to smaller books with thin paper, as the pages can pull loose. Another method is to use adhesive to hold pages back-to-back. Each sheet is only printed on one side.

A single-project book by graduate student Serene S. Al Srouji (Figure 6-15a–c, page 68) showcases a graduate thesis project—the development of a new Arabic type font. The horizontal 6" × 12" inkjet printed book was assembled by adhering each spread back-to-back with its adjacent spread, with the cover mounted to the first and last spreads. The book makes use of a consistent grid, giving each page a uniform hierarchy of diagrams, variations, and finished letter. The book opens

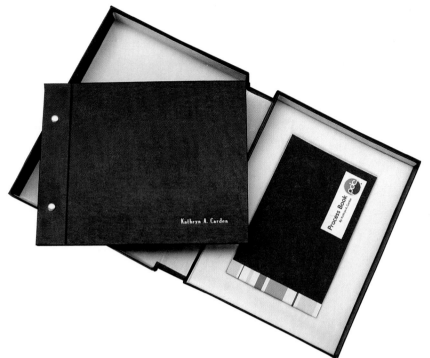

Figure 6-9 Three traditional techniques are employed in this portfolio: a clamshell box, containing a hardcover, post-bound book and a softcover side-stapled process book with a wrap-around softcover. The striped paper is attached on the front and wrapped around to cover the spine and back, effectively hiding the staples used to bind the book. The cover is foil stamped by a commercial binder with the student's name, and the process book is held in place in a recessed well in the bottom of the box. Box: 9.25" x 12", portfolio book: 8.75" × 11.25".
Kathryn Carden, Bradley University, Peoria, IL

Figure 6-10 By using the divided spiral binding, it allows the two sides of the spread to flow together visually.
Kimberly Melhus, Bradley University, Peoria, IL

with a discussion of the nature of script fonts and closes with views of the thesis exhibition.

This method of binding is only as secure as the adhesive that is used. Since the pages are doubled, it tends to produce somewhat stiff pages and so is not particularly suited for larger books.

By applying the adhesive only to the edges of the pages, it keeps the book more flexible. Mary Rosamond uses a form of adhesive binding to affix only the edges of the pages. They are perfect-bound using a flexible bookbinding adhesive at the spine, and short endpapers are used to attach covered book boards for front and back hard covers (Figure 6-16a–b, page 68).

Many designers find this method of printing and binding more intuitive since you can design and print the two-page spreads intact and bind them together. If you need to change a page, you can reprint that spread and not have to worry about what is on the back of the page. The folded spreads are attached together accordion-style, and then folded together (Figure 6-17a, page 69). Adhesive can be applied at the spine, or it can be kept loose. A cover of a thicker stock can be folded and wrapped around (Figure 6-17b, page 69), effectively holding the book together. Alternatively, the end papers of the book can be glued to boards for a hardcover version (Figure 6-17c, page 69). These

Figure 6-11 Several books bound using stab binding or side stitching, a traditional Japanese method of mechanical binding.
Beth Linn, Associate Professor, Bradley University, Peoria, IL

Figure 6-12 Sewing a book using a traditional stab binding or side stitch. There are many variations on the pattern of stitching which can be part of the aesthetics of the book.

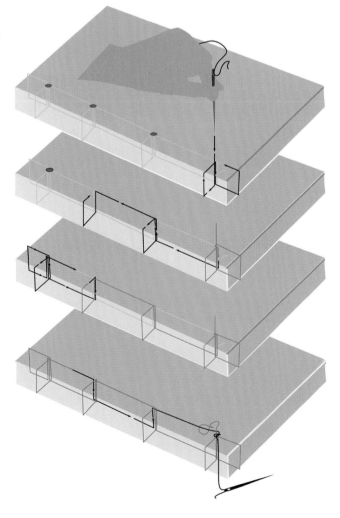

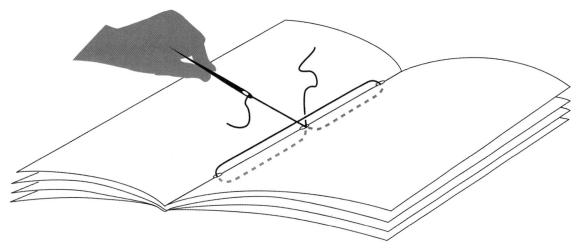

Figure 6-13 Saddle stitch technique.

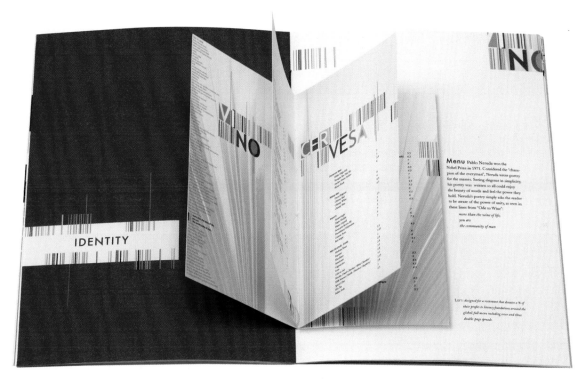

Figure 6-14 An innovative variation on the saddle-stitched single folio format. The portfolio, contains six projects, each with its own two-page spread. Two of the spreads have smaller booklets attached. One is the small version of a catalog, and the other shows a sequence of a magazine spreads 8.25" × 12.5". Carol Herbert, University of Georgia, Athens, GA

boards can be covered with cloth (preferably book cloth made specifically for this purpose) or specialty papers.

A note about adhesives. Since you are designing the entire experience, keep in mind that when you use large quantities of solvent-based adhesives like spray mount or rubber cement, your book can continue to emit a noxious smell every time it is viewed. To be kind to your reader, yourself, and the earth, look for some greener adhesives. Cold-mount adhesives have fewer volatile chemicals and make a better bond. They are particularly suited to the kind of edge binding as shown in Figure 6-16a on page 68.

Polyvinyl acetate glues (PVA) are used extensively in bookbinding for attaching end papers to boards, for gluing cloth to boards, and it may be mixed with a cooked wheat paste for more extensive areas where a thinned, more workable glue is needed. It is water-based and generally regarded as archivally sound. Most spray mounts and rubber cements will deteriorate and discolor in a short time, and they contain acids that will damage paper. Although archival permanence is not usually a concern with design portfolios, you do not know how long you will need the material, so non-damaging mounting and binding methods should be considered.

a

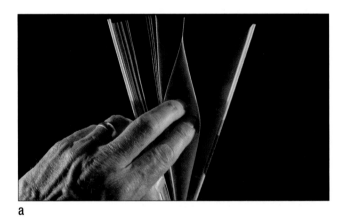

b

c

Figure 6-15a to 6-15c This graduate student's thesis project book shows the development of an original Arabic type font. The long horizontal format and bold fields of red and white reinforce the formal layout. A page is devoted to the development of each letter and shows variations in the design with alternate versions of each letter designed to connect with different letter combinations. Pages are 6" × 12", inkjet printed, and bound by spray mounting each spread back to back with its adjacent spread. The cover is mounted to the first and last spreads. 36 pages consisting of 18 spreads plus cover.
Serene Al Srouji, University of Texas, Austin

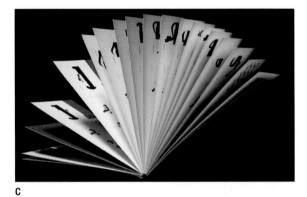

a b

Figure 6-16a-b Details of binding. The page spreads are printed single-sided, folded, and attached back-to-back with adhesive only at the edges and at the spine. (See Figure 5-7).
Mary Rosamond, from Washington University, St Louis, MO

There are many forms of books and bookbinding, including traditional cloth and leather-sewn binding. Although quality binding is essential, keep focused on the design function of the binding system—to serve as a frame and support for your work. The binding should not attempt to steal the show!

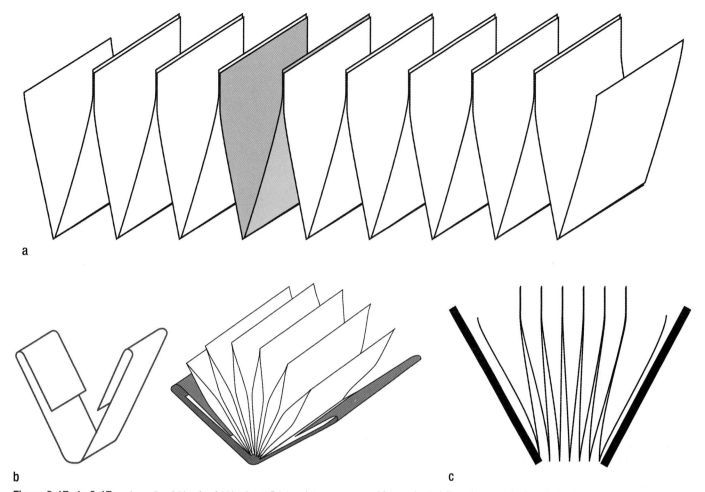

a

b

c

Figure 6-17a to 6-17c Accordion-fold or fan-fold books. **a.** Print each two-page spread for your book. Adhere the pages, back-to-back. **b.** When the entire book is assembled, a cover can be made to fold around the entire stack to hold it together. The spine can be held together more securely with a little PVA (polyvinyl acetate) glue and some cloth to make it more secure and flexible. **c.** Hardcovers can be attached by adhering the end pages to book boards. The boards can be covered with book cloth or suitable paper.

Printing

Paper and paper size. In selecting paper to print your portfolio, pay particular attention to standard sizes, thicknesses, and finishes. For high quality printing, it is good to explore the range of papers designed for laser or inkjet printing. Matte coated papers designed specifically for inkjet have a smooth, non-glare surface and good ink holdout that results in excellent color saturation. Most sizes and weights are available coated on both sides for printing back to back.

Glossy finished papers tend to damage more easily, have a tendency to crack when folded, and are generally less suitable for book projects. However, they may be used for contrasting pages, for printing mockups of labels or other items that might be mounted or tipped into a book page. Offset printing papers, coated or uncoated, may be used for inkjet or laser printing, but results may vary widely. Some high quality uncoated offset papers produce excellent prints, and the tactile quality of the paper becomes part of the design statement. The portfolio book by Caspar Lam in Figure 1-6

was printed using Mohawk Superfine 100 lb cover and 100 lb text.

Alternative paper stocks, such as vellums, metallics, textured and colored papers should be considered for accent or variety. We certainly do not want to discourage experimentation and creativity! Test printing is, however, always a good idea.

As discussed earlier, except for leave-behinds or teasers, page sizes smaller than 8" × 10" will probably not show off graphic design work to its best advantage. The standard letter size (8.5" × 11") or the A4 size may be too common to get noticed. A suitable size for custom-printed work seems be the 13" × 19" paper. Many newer-generation inkjet printers can handle this size; and folded in half, it yields a respectable 9.5" × 13" page. This size also conveniently corresponds to a standard portfolio case that comes 13.8" × 19.8" inches.

Large format roll printers. These printers can output from 24" to 52" wide paper. Most of these can only print on one side of the paper. This is not a problem if

your book uses page protectors that only allow one side of the sheet to show. If you are making a plate portfolio, it allows you to print full-size composites and mount them flush to the edges of your boards. Large format printing allows for the possibility of French folded pages. This is similar to the accordion book, but instead of each sheet being folded toward the printed side, it is folded outward. This saves having to use adhesive on the pages edges. The folded pages are then gathered and bound at the spine.

Getting the most from your printer. If you are printing from your own or from a school printer, you may not be getting the best quality color match. Two things that can be done to improve the quality of the out put are: Color calibrate your monitor. (There are some inexpensive calibrating hardware and software tools on the markets specifically for this.) Find the correct ICC printer profile to match the combination of paper and ink that you are using. (You can start by checking on the Website of your printer's manufacturer for their recommendations.) Your printer will have a different response to each paper and ink combination. We do not have the space in this book for a full discussion of printer optimization, but it can significantly affect the quality of your printing. Most major suppliers of printers and printing supplies can provide the profiles to match their papers and inks. You will have to download the needed ICC (International Color Consortium) profile and install it on the computer from which you are printing.

In Mac OSX, printer profiles should be installed in the directory Library/ColorSync/Profiles. Use the ColorSync Utility to make custom or advanced settings.

In Windows XP and Vista, use the Color Control Panel Applet to install and manage printer profiles. There are resources for learning more about color management. These are some of the reasons quality may vary tremendously depending on where you have your printing done. Be aware that you may be showing your work to art directors who judge print quality daily.

Local copy shops. Retail copy centers have sophisticated machinery, but often it may not be maintained or carefully operated. If you are going to have your work printed at a service bureau, make some inquiries among local designers or architects to find out which places are accustomed to doing short run, high-quality custom presentation material.

Once you have established how and where you are going to print your work, you must deliver your files. Be sure to preflight your files and package them so all of the fonts and linked files are present. Find out if the printing service has a preference for file formats: InDesign files or PDF are the most common for documents that involve pagination. Your binding method will affect how you print. If you are post-binding your book, make sure you leave enough of a margin on the side that will be in the binder. French folds are usually side-stitched, post- or ring-bound.

Print-on-demand services. One method of printing portfolios and process books that has emerged is a range of competitively priced single-to-short-run printing services. These are capable of producing high-quality printing and binding. The books, shown in Figure 6-18, demonstrate some of the sizes that are available. The advantages are that for less than the cost

Figure 6-18 Three hardbound books printed by online printing service. Reasonably priced with quick turnaround time, these services can produce short runs or even individual books for a very reasonable price in a range of sizes and bindings. Shown are three books printed by Blurb.com.
Cover designs by Robert Rowe and Joshua Newton, Tidewater Community College, Norfolk, VA

a

b

Figure 6-19a and 6-19b Portfolio pages showing editorial, poster, and skateboard designs. Page size 9" × 14".

Printing: Blurb.com. Design: Joshua Newton, Tidewater Community College, Norfolk, VA

of the paper and ink for a personal inkjet printer, this service will produce an offset printed hardbound book, plus dust jacket. Joshua Newton (Figure 6-19a–b) makes use of the 9" × 14" book format that allows the book to be printed and bound with a hard cover and dust jacket. This makes producing multiple copies very easy. Some of the University of Illinois process books (Figure 4-1) were produced in this manner.

Print in a Web World

Web designers and developers should not discount the value of having a simple well-designed print package to send out or leave behind following an interview. Jim Ferolo, interactive designer and chair of the Multimedia program at Bradley University states, "Clients love to get print material. First, it is easy to view, and second, it allows sequencing and documenting your work. A simple printed folder with a slot or flap to contain a CD or DVD can hold the résumé, cover letter, and a couple of printed pages of sample images representing your work. Screen shots of Websites or animations can serve as visual reminders of some of your strongest work."

In the hurly-burly rush of deadline-focused IT projects, niceties like disk labels may not seem important. But in a competitive situation, presenting yourself as being professional and organized is one more thing in your favor (Figure 6-20). Russell Cole, interactive designer at Holler in London, UK, comments "If you are showing interactive/motion work, I personally prefer to see screen grabs on paper or as a PDF with a link attached so I can go on to view the work on screen

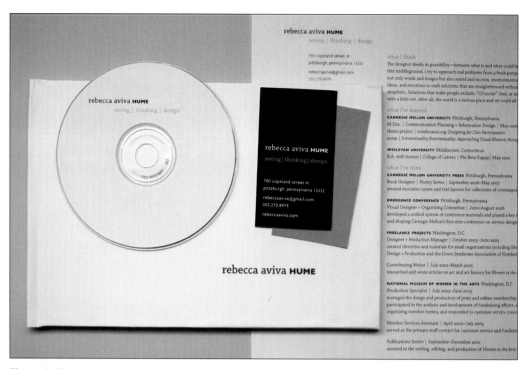

Figure 6-20 Portfolio book and CD with résumé.
Rebecca Aviva Hume, graduate student, Communication Planning + Information Design, Carnegie Mellon University, Pittsburgh, PA

should I choose to. This is a much easier way of getting your work across and therefore more likely to be successful; a lot of studios don't have the time to sit through multimedia presentations or showreels the length of major motion pictures."

Even heavily IT-oriented companies have to make client presentations, and these are often enhanced by presentation folders. If a company recognizes the value of design—and most companies do—your efforts will not go unnoticed.

The Interactive Environment 7

Maintaining an online presence is essential for both traditional print designers as well as those working in interactive media, but there are differences in portfolio strategies between graphic designers and interactive developers. For the strictly print designer, the Website provides viewers immediate access to samples of work that hopefully will make them want to see the originals. For the interactive designer/developer, the Web portfolio may be the main portal to interactive projects and other sites that together create an online identity. Your site should be designed with your career goals in mind and should reflect your mix of skills and interests. If you are new to the Web, or if your goal is to focus maximum attention on your work, the best advice is to keep it elegantly simple. One such site belongs to photographer Neil John Burger, whose Chicago studio does a range of commercial projects. Very little comes between the viewer and the sharp clear images. The only other element on the screen is a discreet Flash menu bar of thumbnails that are organized into the most basic of categories: people, places and things (Figure 7-1a–b). How complex should your portfolio Website be? At its most basic level, you need a link to the work, to a résumé and contact information, and a link back to the home page.

Of course, the Web can be used for much more than simply a slide show, and designers of all stripes should be open to its creative and interactive possibilities that can be served up through rich media Web applications.

As a creative visual communicator, creative strategist, or art director it is advantageous to show that you can harness some of the potential in the wide spectrum of new media.

Everyone Needs a Website

Many firms hiring graphic designers or interactive media designers/developers now request that applicants provide a URL for a Website with samples of work along with a cover letter and résumé. Here are a few things for everyone making a portfolio Website to consider. Be very clear about the purpose of the site as you are creating it. That purpose should be immediately clear to the visitor as well. It may not be a good idea to make this a personal multipurpose Website with pictures of your dog, your friends, or spring break trip. Although many people are in fact doing just that, you should consider this very carefully. If you direct people to your site through your résumé or portfolio, it is a part of your professional presentation. The emphasis therefore should be on your work and the URL should take them to images of your work with as few clicks as possible. If you are still in school, get a Web hosting service off campus so you can begin to give out contact information that will not have to be changed when you leave school. It is also more professional to have your own domain name, but choose it with some care.

a
b

Figure 7-1a and 7-1b Website for photographer Neil John Burger focuses attention on the images.
Designed by StaticFrame, Chicago, IL

A word of caution, and one cited by many professionals, is to be careful of what you post on any site. Potential employers are likely to search under your name. Do not vent your anger against current or former employers, and do not go off on unreasonable rants. In short, do not put anything on the Web that you would not want a potential employer to see or read. You can keep totally separate sites for personal and business uses, but be aware that nothing on the Web is ever truly private.

Content. So what should be the content on your site? If you are referring a prospective employer or client to your site, it should present an organized and labeled set of links to your work. These can be thumbnail images or text links. There should be a viewable résumé, a downloadable résumé, and a downloadable portfolio. The site may also include video or Flash animations, interactive elements, and links to external URLs. Larger projects, such as interactive environments, installations, or performances may need to be documented by video or a more extensive gallery of still images and narrative. Your site, while maintaining its professional focus, can have links to process information, industry-focused blogs, and resource-sharing services such as Del.icio.us, Flickr, or other social or professional networking links. In choosing whether to include this additional content on your site, question the extent to which the information provides insight into your professional work. Decide on your target audience, and base your content decisions on what your audience will want to see, not on what you want to show. It has become popular among new media designers to aggregate information of different sorts on a personal site. If you are promoting

yourself as an interactive developer, then an intricately constructed site makes perfect sense. If you want people to view your print, illustration, or photography, then other content will be a distraction.

The well-organized Website design by Joel Raabe, (Figure 7-2) keeps a professional focus, is easy to navigate, and shows a range of projects. It opens with a clean, fast-loading mostly typographic page that announces his name and what he does—multimedia design. The portfolio link at the top takes the viewer directly to audio projects, which is currently Raabe's main professional involvement. The pages under the other media: video, graphic design, and photography, are all structured efficiently using the same grid structure. Sites like Raabe's, which employ a database (his uses PHP and MySQL), make it easier to maintain consistency across a number of links since there may be only one page and the content is dynamically loaded in predetermined content fields.

James Ferolo, interactive media designer and chair of the Multimedia program at Bradley University described the process like this: "I look at applying for a job as a two-stage process; first you set the hook online, then land the fish face-to-face. The initial contact with most companies is by letter via online application—a very well-written letter and a URL. Your online portfolio Website will contain a variety of information that focuses on your specific skill set as a designer, developer, producer, etc. Once you get an opportunity to meet a potential employer in person, the best approach is to begin showing your strongest samples related to the open position and see what the viewer responds to. Once you know what they are looking for aesthetically and technically, you can direct them to specific sites, or, as often is the case, I will have my

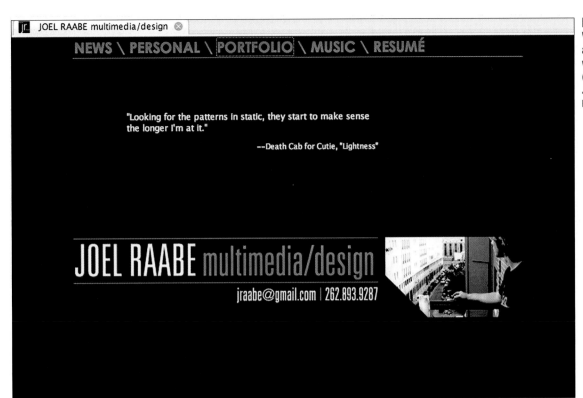

Figure 7-2 Multimedia Website for an independent audio producer living and working in New York City. (See also Figure 1-5.)
Joel Raabe, Bradley University, Peoria, IL

laptop, and I can run the specific demo or example offering commentary on my roles, responsibilities, and achievements related to that project."

Interactive Designer/Developer Portfolios

The professional landscape in interactive media design is somewhat different from that of traditional graphic design. It is a newer professional community and more likely to enthusiastically embrace new modes of communication and to appreciate new programming strategies. Perhaps more than in the print and advertising areas, the interactive design community is bound together by formal and informal professional networks. Through these networks, programmers, developers, and designers keep up with current trends, solve technical problems, and exchange information vital to their professional development. Many current developer sites are more like blogs than traditional galleries or portfolios. Trends seem to be set by leading professionals, and this can have a trickle-down effect through the online community. Eric Meyer, in a 2005 posting titled *Thoughts on Social Protocols* used the term "identity archipelago" to describe how identities are created and maintained. "By creating symmetric links between the islands, the author can make it possible to consolidate the various pieces of his online identity into a more cohesive whole." Your online presence reinforces your profes-

sional credibility. As Kevin Reynen, an interactive developer relates: "In my world, presenting at conferences, writing tutorials, and sharing source code is really how we are evaluated. Any potential employer can look at the code I write."

MEDIUM*rare* is a partnership of Pratt graduates practicing in New York. Their Website (Figure 7-3) dishes up a lot of information right from the opening screen, but does so in a clearly organized hierarchy that avoids confusion. An impressive graphic poster sits atop a thumbnail grid representing and linking samples of 18 projects. Small text to the right of the poster image gives project information. The size of this type, its proximity to the image, and its flush left alignment make it a subordinate part of the large image and so it does not look like an unrelated text column. The site, following the model of many new-generation design sites, delivers up news in the form of a blog in the left column; but since the text is small and aligned flush left, it stays visually distinct from the image portion of the page—it is clear that it is information of a different order than that of the image caption. This amount of information, with less deft handling, could produce a muddled site; but MEDIUM*rare's* site, if you will pardon the pun, is very well done! The site has only three links (*about*, *contact*, and *news*) in addition to the thumbnails. It follows the directive of putting the work out in front. There is good music on the videos, and the clean

white background and reserved type treatment only make the fine work look that much better.

The Branded Website

Regardless of how visually rich or how minimal your site design, it can still have a branded look that conveys a sense of personal identity. If someone looking at your paper résumé goes to the URL, there should be a sense of recognition: both to inform the person immediately that it is indeed the correct site, and to demonstrate that, as a designer, you can carry a design theme across different media. It can be as simple as a specific combination of fonts, images, colors, and textures that relate to your portfolio. Chris Free (Figure 7-4) uses a textural theme to unify the pages of his site.

It is considered important in both print and interactive environments to closely align the visual and conceptual design of all collateral material across media. Therefore

it is advantageous to demonstrate an appreciation for this by coordinating your Website, résumé, letterhead, and portfolio. Proportions, margins, rules, tone, and texture can contribute in subtle ways to a recognizable experience.

Some people have designed their Websites to resemble the physical properties of their print book. Toby Grubb, now a designer with Burton Snowboards, created this Flash site as part of his portfolio presentation in his senior year at Bradley University (Figure 7-5a–d, page 78). The pages of the book on the Website appear to turn in a simulation of a real book. It is very similar in appearance to the actual promotional book he created (see Figure 8-1 in the next chapter); however, the Web version has the added advantage of allowing the viewer to scroll vertically through several images of each project. Mapping the conventions of one medium on another is considered by some interaction designers to be a questionable practice. It seems to occur often when an unfamiliar technology is

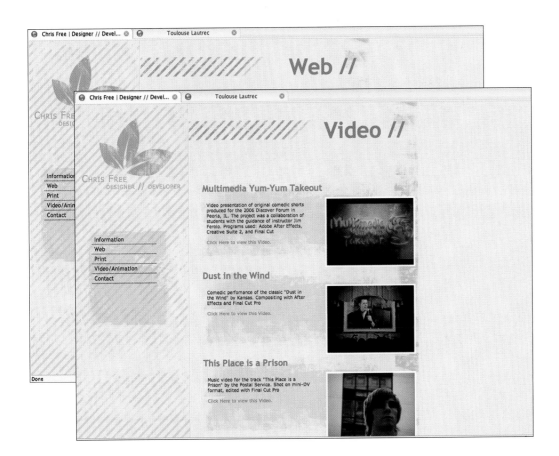

Figure 7-4 Portfolio Website for Web designer/developer Chris Free; identified by textured background, color theme and pattern of diagonal stripes. The site makes use of CSS and PHP to dynamically load content.
Christopher Free, Bradley University, Peoria, IL

first introduced. User interfaces modeled on the expectations and behaviors of more familiar objects, such as animated buttons and switches, so popular in early Websites, have given way to simple text links. Responsive and engaging interface designs remain an important feature of many products, for example, most digital cameras employ a reassuring and quite functional sound effect that imitates a mechanical shutter.

Kristen Ley's Website (Figure 7-6a–f, page 79) is very close in design to her printed portfolio booklet. The Website consists of images of each page of the branded résumé booklet, echoing the tag line "Fall in love . . . with design." The pages bear the same textures and nostalgic images while linking to areas of education, experience, awards, and all else on the résumé. The final page contains links (in the form of black dots) to each item in the portfolio. What could be a distracting image of the romantic couple (there is a different image on each page) actually directs attention, by the direction of their gaze, to the field containing the portfolio images.

Designing Your Website

The basic Web gallery. Your Website does not have to be fancy, but it does need to be thoughtfully designed. Major vendors are continually improving

commonly used software for creating Web pages from preformatted templates. These will continue to provide a gateway to Web development for the uninitiated or those who do not want or need to market their Web design skills. As one might predict, those in the creative professions will look for ways to distinguish their sites from the generic formats and templates. While much lip service is given to the notion that all that really matters is seeing the content, the observation by Russell Cole reveals an underlying attitude of some in the visual design community: "While your site needs to be simple, please DO design it. I've seen a recent spate of folio sites; a lot of them use a common, shareware template. I generally come to one assumption when I see work presented this way—the designer is lazy!" Although this is less of an issue among the community of developers, even for those using software dominated by "themes," it is still possible to make better or worse aesthetic choices. Some designers/developers are using programming and coding to create new and responsive interactions. Just bear in mind that the same logic that would argue against using a clever experimental type font for your résumé would also preclude employing an unfamiliar user interface design as the primary navigation on your portfolio site. Save it for use in an applied project for which it is truly appropriate.

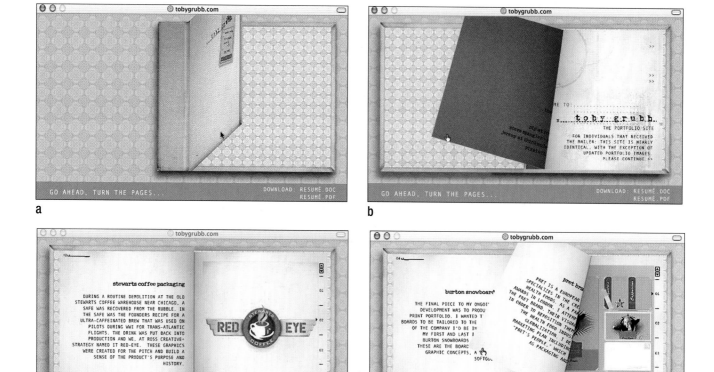

a

b

c

d

Figure 7-5a to 7-5d Self-promotional Website designed in Adobe Flash. The site is designed to closely resemble the branded look and feel of the résumé package (see Figure 8-1). The interaction involves the simulated turning of the pages to advance through the site.
Toby Grubb, Bradley University, Peoria, IL

A brief survey of some of the methods for creating Websites is shown in Table 7-1, organized from the relatively simple to the more complex. The important thing is to make an informed choice of what method to use based on your goals and your capabilities.

Site Structure

Many of the qualities of a well-crafted Website can be experienced on the Rebecca Aviva Hume's Website (Figure 7-7a–d, page 80). Once the site loads, it has elegant typography, white space galore, and a grid of thumbnails (Figure 7-7a). The navigation bar at the top of the Webpage, with its dropdown menu, allows the viewer to select subsets of the thumbnails of projects based on major functional categories, like information, interaction, identity, and—in acknowledging the importance of writing—a link to three writing samples. When a category is selected, the thumbnails relating to that category are highlighted and the others are faded (Figure 7-7b). Each project has several additional images that could be viewed. A simple paragraph tells the story of each project without intruding on the space of the main image. I do find that an indication of the number of subimages in any set is always helpful. The projects are superbly photographed and give just enough information to communicate their quality (Figure 7-7c–d).

One site that is exemplary both in the quality of work shown and the elegant presentation is that of illustrator Jean-Etson Rominique Paul in Figure 7-8a–c, page 81. The URL goes directly to an illustration on a subtle green background with a series of round thumbnail links at the bottom of the page. Contact information is provided in a large yet unobtrusive type font—demonstrating that despite the fetish many designers have for ultra-small type, well-spaced classic letters can convey professionalism as well as be readable. The site does have one feature that shows a canny sense for what people want to see. Each image page provides a link that shows some of the sketches that led to the final image; but these are only shown if one chooses to click on the "sketches" link; the process sketches do not intrude on the initial enjoyment of the image.

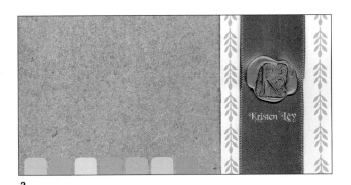

a

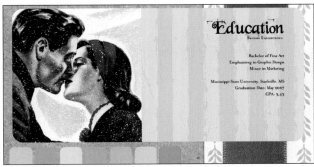

b

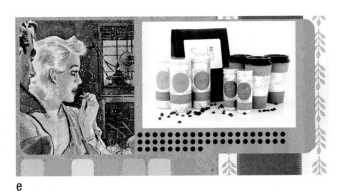

c

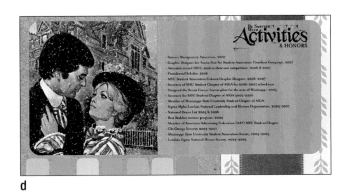

d

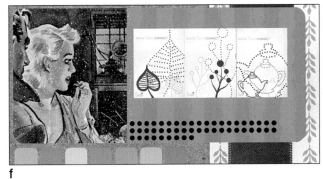

e

f

Figure 7-6a to 7-6f Flash Website with résumé and samples of work. Design for the pages closely matches the color and materials of the physical résumé booklet. Rollovers on the colored tabs at the bottom bring up menu options. When the page is advanced, the next page springs into view from beneath and comes to rest after a quick bounce. Some pages have a scrolling text box. Each page has a retro image of a couple, reinforcing the theme of "Fall in Love . . . with Design."

Kristen Ley, Mississippi State University, Starkville, MS

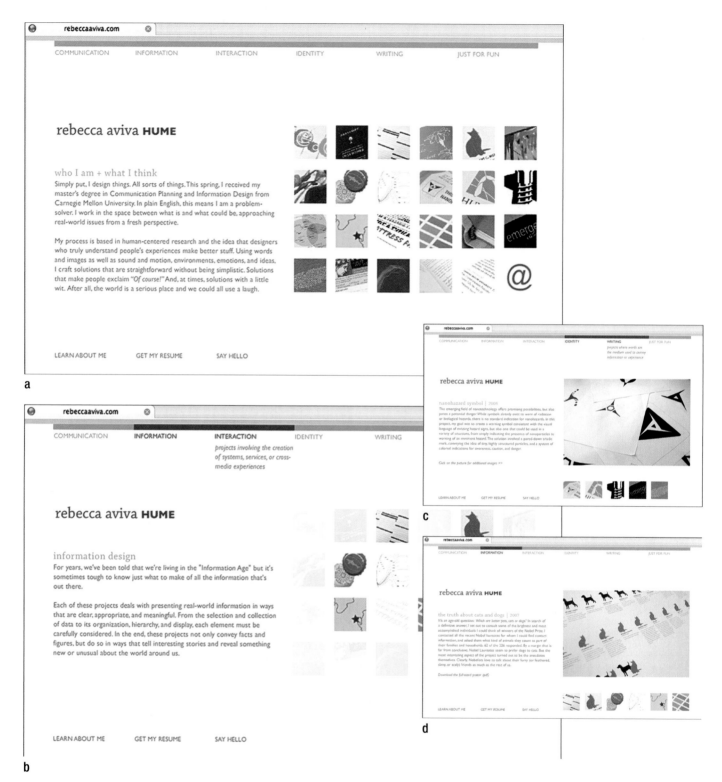

Figure 7-7a to 7-7d Portfolio Website.

Rebecca Aviva Hume, graduate student, Communication Planning + Information Design, Carnegie Mellon University, Pittsburgh, PA

Jiminie Ha's portfolio from Yale University (Figure 7-9a–b) deflects attention away from the technical aspects of Web design by making use of a simple horizontally scrolling series of images with a band of labels at the top. The unpretentious technique belies the complexity of the work on the site. Ha addresses both practi-cal problems of visual communication and also ventures into the realm of oppositional design. Ha alternates clearly applied designs, such as lecture series posters, with experimental forms such as videos and installations that seem to challenge design's commercial role; and in doing so, invites the viewer to consider the practical

a

b

c

Figure 7-8a to 7-8c Illustration portfolio featuring eleven illustrations along with process sketches. This site adheres to a philosophy of "simple is best," putting the emphasis on the work itself.

Jean-Etson Rominique Paul, Pratt Institute, Brooklyn, NY

possibilities for the experimental work and experimental possibilities inherent in the seemingly practical items.

All aspects of your portfolio should meet professional standards—and this applies to your Website as well. You may want to consider making use of expert services. After all, most commercial sites are the results of design and development teams. Be sure to credit any collaborators. Rather than diminishing your credibility as a designer, choosing to collaborate can show your

understanding of the realities of producing a professional product. Knowing when to go for help shows mature judgment.

Differences Between Print and Web

Much has been written about the differences in design criteria between Web and print design. Some of the differences can be observed in the Website designed by

a

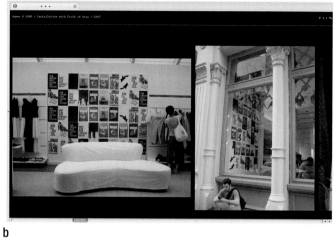

b

Figure 7-9a and 7-9b Website consists of a long horizontal scrolling page. Shown are lecture series posters in which each poster expresses the individuality of the speaker; and "Installation with Field of Gray," Agnès b., a boutique in New York City.
Jiminie Ha, Yale University, Graduate Program in Graphic Design, New Haven, CT

Kjell Reigstad shown in Figure 7-10a–f. In designing for the screen, one has to respect the horizontal format. Although pages can scroll, important content generally fares better "above the fold." This is a phrase borrowed from newspaper design and refers to the area of the page that appears in the browser window when the page is opened without having to scroll down. On most contemporary computers, it is safe to assume the window will be no smaller than 800 × 600 pixels, and many sites are optimized for 1024 × 768. If your page does scroll, design the format of the material "above the fold" to appear complete and not cut-off.

With print formats, a page is a fixed size. That is not always the case with digital portfolios. Lines of text type that reflow to the full browser width become difficult to read and destroy any consistency in your layout. From a visual design standpoint, a viable solution is to lock the dimensions of content areas so they do not change width as the browser window changes size. Many portfolio sites use a page that is fixed both in height and width and that stays centered in the browser window.

On the development side, "fluid" layouts that employ minimum and maximum widths or values that are set to a percentage of the browser view are sometimes implemented. By carefully setting limits and linking parameters for fonts and other display qualities together, these techniques, coupled with an understanding of visual design, can create an attractive and responsive site that takes advantage of the intrinsic flexibility of the medium.

On a Website, you cannot tell how many pages there are, as you can with a book. It shows good design awareness to anticipate the concerns of the viewer by providing an indication of how many images there are

to view in a given set. If the interface has a "next" and "previous" button, it is very helpful to indicate the total number of images and which image you are currently viewing, for example "3 of 7," or "1 of 200." I find that I am personally more inclined to click through all the images if I know how many there are; if I don't know, I usually only sample a few. The user should always know where he or she is in the site, and know exactly how to get back to any other part of the site. A term for this is "situation awareness" and is described in Designing for *Situation Awareness: An Approach to User-Centered Design*, by Mica R.Endsley, Betty Bolte, Debra G. Jones. This technique is demonstrated again on Kjell Reigstad's site (Figure 7-10), as well on many of the other gallery sites illustrated in this book.

Attention to details of typography is as important in Web design as in print. With current style rules present in Cascading Style Sheets, level 2, you have the ability to manipulate line spacing, word spacing, character size and many other design elements with great precision. A CSS, level 3 comes into practice, these will become more finely tuned. It is still a good idea to use screen-friendly fonts such as Georgia, Verdana, and Trebuchet for text that is twelve point or smaller. Stark color contrast, and reverse type can adversely affect readability, so keep the black backgrounds and Gothic Blackletter fonts for some of your music industry clients, but don't use them on your own site.

Usability and Web Standards

Making your site compliant with current best practices in Web design is a must. One of the fundamental principles of standards-based design is the separation of

Figure 7-10a to 7-10f This site combines sound usability features, including a fixed height and width, presenting only information needed, and indicating how many examples there are of each project. Large words appear as the user moves the cursor over each menu item: "produced with ink" identifies print, and "design in the fourth dimension" identifies video. Thumbnails link to larger images of projects, and each enlarged view has navigation links to the next item in the series without going back to the thumbnail menu.

Kjell Reigstad, Pratt Institute, Brooklyn, NY

style from content; or more precisely, this means putting the specifics of font size, background color, even layout and positioning, into separate style sheet documents that are linked to the page. This facilitates editing, since one style sheet can control multiple pages—in fact, by changing a style tag for example, font size, on one style sheet, it can update the font size on all the pages across the entire Website.

Updates and maintenance are made much easier since the markup, uncluttered by outmoded font and table tags, more clearly reflects the semantic structure of the content. And since one style sheet can provide presentation information for an unlimited number of pages, it facilitates consistency among pages. On the Web, your code is open for all to see. Careless coding is the equivalent of poor craftsmanship in traditional media. Your site is a sample of your work, so if it is cobbled together using outmoded <table> and tags or unnecessarily complex markup, it will reflect poorly on your ability to implement professional sites. Another sign of professional awareness is the degree to which you comment your code so that someone else can perform editing and site maintenance.

Styles can be changed without altering the content of the site at all. This has great potential for customizing display to comply with different accessibility concerns such as the need for large type for some readers. Reece Quiñones uses this to good effect by giving the user the option to select from three different moods for his site (Figure 7-11a–c). This puts the choice of style in the hands of the user. The next step up from this is a "smart" site that processes the user's data requests, senses the device or platform the user is viewing from, and selects the most appropriate template for that situation using the "media" attribute.

Bandwidth and resolution that seemed impossible a few years ago are now standard, and video streaming will only increase in ease, speed, and quality. Although most companies looking at your work will have high-speed connections, downloads can still slow to a crawl at times. Your Website can demonstrate your understanding of best usability standards and practices. This includes using "alt" tags for images and download indicators for large multimedia files that load in Flash. Your site should be built using robust and tested protocols and file formats and conform to accessibility standards. If you are promoting yourself as a Web developer, be sure to test your site's Web standards compliance with one of the W3C (World Wide Web Consortium) validation Websites.

Once you have your site up and running, it is important to keep it current. Sites that connect to a database on the back end can make use of programming in PHP or other scripting languages as well as Flash and Flex with XML to create new pages on the fly, to have the content searchable, and to develop a content management system. Flash, ideal for creating rich visuals and interactions, has been traditionally more difficult to link to other sites and more cumbersome to update. It continues to show improvements in external data connectivity and particularly in its ability to have linked content deep inside the site be accessible to searches.

There exists an extensive community of users who contribute to the large pool of open-source software being developed for the Web. Designers and developers like Jonathan Keller are employing new open-source content management tools and blogging platforms for updating content in their portfolio sites.

Keller's site (Figure 7-12a–d) employs WordPress to post information and to allow viewers to respond. And respond they have! There are, at the time of this writing, 26 projects featured on the first page of Keller's Website (Figure 7-12a). Next to it is a column indicated by a red title bar for blogs; next to that is a column for information on the designer, the site, recent posts, and a search function. At the very top of the site is a drop-down menu to allow the user to search by project. Powered by WordPress, a popular open-source blog engine, each of the projects has its own comment field. Keller finds the feedback from viewers important in disseminating the ideas through a public forum. He reports that "it creates a desire for people to return to the site to see what new things are in the works . . . and in the case of projects like the 'Slitscan Type Generator' (Figure 7-12b), it allows for a greater amount of interaction between people who are willing to take part in the project." The "Slitscan" project allows users to download custom imaging software with the agreement that they then post the results back on the site.

His vortex-like data-rendering (Figure 7-12d) plots the frequency of repeated words in different literary works. These kinds of visualizations, like those of Robin Peeples in Chapter 4, often require some explanatory text. About his interests, Keller states, "Data visualization is definitely a big interest of mine. I use it as a means of exploring hidden structures within systems. In the case of 'Volume Redundancies,' I was interested to see what a body of text would look like in 3-D space. Typography is perennial because type is encoded with such an amazing amount of communication/miscommunication that the number of hidden structural elements is endless." One distinctive quality of his methodology is his interest in recording, almost obsessively, something every day. Perhaps one of the most striking items on his site is his 8-year series of daily photos, compiled into a time-lapse video (Figure 7-12c). He also posted this project on video-sharing sites, where it has gained a worldwide audience.

New programming languages and frameworks will become fashionable only to be superceded by another generation of development tools. Jonathan Keller is optimistic about developments in open-source applications. The best advice for designer/developers seems to be to keep current on events, to be an active participant

Figure 7-11a to 7-11c This Website makes use of cascading style sheets (CSS) to give the user the option to change the design of the site from a warm, calm look to a frenetic overwrought look suggestive of the result of an all-night work binge, effectively demonstrating some of the implications of external style sheets.
Reece Quiñones, Pratt Institute, Brooklyn, NY

in professional dialogs, and to understand basic programming structures.

A Higher Level of Hierarchy

Just as in print graphics a designer develops a grid or page template for specific sections of a magazine, developments in Web design allow the Web developer to create templates for different kinds of information. If a user clicks on a link, with dynamic data, that click sends a query that pulls the specified information from the database and fills the page with new content. With a newer generation of Web tools, the query can also specify the category of information and choose the preferred template for that type of information based on conditional tags. It knows, in other words, if it will be

a

b

Living My Life Faster: 8 years of JK's Daily Photo Project

The video at the right is hosted on Vimeo which, of the services I am using, has the best Flash video quality. You can also find the video at Google Video (good), or Yahoo Video (good), or YouTube (okay). Though, if you want the best quality online you can get the QuickTime from my site.

The project condensed to 7 images:

c

d

Figure 7-12a to 7-12d Website that combines an ongoing series of projects, user input, and other rich media functions.
Jonathan Keller, Cranbrook Institute, Bloomfield Hills, MI

displaying images, animations, text, or a home page and selects the template most appropriate for that content. Rather than create individual pages, the designer creates themes that style the overall look of the site and a hierarchy of templates to display the information in the way that is most appropriate. This capability is built into the latest generation of blog and content management software.

Why are we explaining all this now? Because as a designer you may find yourself working on Web development teams; and it will be useful to understand how sites are constructed so you can effectively design for the team. Additionally, the advantages of scalable server powered design and development can dramatically increase your productivity.

Many common sites today are not one Website, but an aggregate of Web information. Content aggregators or "mash-up" software applications are currently available from major vendors. Many social networking sites (Digg, Del.icio.us and Flickr) currently allow content hosted by them to be aggregated, or included, in mashups. By creating an aggregated site, you are bringing into one location the various elements that you want to comprise your site. Basically it allows you to customize the content of any site by drawing information from any number of sources.

Obviously this last set of options is not appropriate for everyone; but if you are intent on displaying your blog, linking to a range of projects in progress, and tapping into RSS (really simple syndication) feeds that supply continually updated information, like news and weather, then this approach to Web development is definitely for you!

With all this talk of programming and design strategies, keep in mind that it is the individual who is being hired and not the Website. Chad Udell, Web designer/developer and educator, advises, "Consider the viewing of your portfolio as a one-way conversation with a potential employer. The content of your site is as important as the discussion that takes place during an interview. If you cannot accurately describe or explain the process used to create the site you are developing, think twice about employing a specific technology that seems mysterious to you. Try out and master the language, tool, or API you are contemplating before using it as a foundation for a conversation that you will inevitably have with a potential employer." There is no one correct way to create a Web presence. You should use strategies that you have mastered and can do well. If you are not familiar with Website development, keep the site simple and let it showcase your work. Add to the site gradually as you learn. Apple iWeb gives the graphic designer with little Web experience the tools to create a basic Website that is functional, and it provides the tools to upload the site to the Web in one integrated package. This may be all you require for a successful online presence. For the graphically and scripting inclined designer, Flash provides a good system for building visually and interactively rich sites. For the developer community, WordPress or other blogging and data linking implementations will provide plenty to challenge and engage your friends and colleagues.

Table 7.1 Web Development Strategies for Online Portfolios: Listed by Skill Level

BEGINNER

Flickr/Blogger	Easy to use; no service provider needed, free. Disadvantages: generic look, looks like you did not give much time or thought to process.
Microsoft Word export	Produces nightmarishly complex code (not a good idea).
Photoshop gallery	Makes a usable gallery, but still needs to be put into a more branded Website. Can create quick site gallery with minimal preparation of images (automatically generates thumbnails). Markup is complex and not easy to maintain over the long term.
iWeb	Easy to use; good documentation (only on Mac platform)
	Long term maintenance can be difficult, as can insuring uniformity of design.

INTERMEDIATE

Static HTML	Can use a word processor or text editor to edit; some learning required; easy-to-use preformatted templates are available. Can take time to edit.
Dynamic HTML/CSS HTML, Javascript interactivity, and Cascading Style Sheets	May be done in one of many programs—Adobe Dreamweaver may be the most common. Generally standards compliant. Easier to update, provides some interactivity and javascript-enabled effects for viewing images. CSS ensures uniformity throughout site.
Adobe Flash	Can be used to create smooth animations and interaction without getting too deeply into scripting; built-in components may help with standard functions. Design variety and power makes it a favorite of the designer community.
WordPress ands and **Drupal**	Both are open-source publishing platforms that enable you to create a site of varying complexity by installing and activating various modules. Both allow you to customize "skins," update content quickly, post and moderate blog entries and are free; good for professional networking.

ADVANCED

Customized Data-driven Site using PHP, XHTML or XML, and MySQL.	Open-source, and therefore, free; efficient to build and edit. Good for large number of images or rapid changes in content.
ASP	Microsoft's server-side scripting platform; more appropriate for enterprise-level or commercial site development.
Flash	Layout is very stable; motion and interactivity can be highly refined.
	Disadvantages: Editing can be more difficult; book marking has traditionally been more difficult; Actionscript has steep learning curve.
AJAX (Asynchronous Javascript and XML)	Allows faster interactivity without need to refresh screen; provides a more Flash-like environment, but without editing difficulties of Flash. Disadvantage: Cross browser incompatibilities may prove troublesome.
Flex/Flash	Adobe Flex assists in Flash development; assisting in binding dynamic data to Flash site.
	Advantages: All those of Flash plus data connectivity and faster development; good documentation; free developer tools and compilers are available. Easy to "skin" and design interfaces for.
	Disadvantages: Requires advanced Actionscript knowledge.

The Résumé Package and Presentation 8

The final components of the portfolio design and presentation include the cover letter, résumé, and teaser/leave-behind. These reinforce or add to the design voice of the entire portfolio. A summary of the portfolio materials includes the portfolio book or a series of plates, a selection of a few samples of completed projects, a Website, résumé, cover letter, a business card, and a leave-behind.

All of these components should convey a coordinated overall design style or professional voice creating, in advertising terms, a branded experience. This is demonstrated in Figure 8-1a–d by Toby Grubb's portfolio presentation. The experience starts with the miniportfolio or teaser, which contains samples of work, a cover letter, and a résumé. The distinctive visual design and markings on the box and booklet reflect the same patterns, colors, and general design qualities of the main portfolio and the design and interactions on the Website, creating a unique and memorable experience.

When applying to the USC graduate program in digital animation, Renae Radford made sure "everything was nicely packaged, with matching design that went across my résumé, cover letter, breakdown sheets, etc. . . . all had my name, contact information, and Web portfolio address on every page." This is important in any situation where you are sending a package of materials that will be handled by multiple people. Items become separated, put back in upside down and backwards. Submitting an organized presentation package goes a long way to having your work regarded seriously.

The Résumé Package

Consider a typical creative director checking his/her morning "snail mail." Among the invoices and direct mail appears a tactile, nonconformist package. Once opened, the package reveals a business card, a well-written cover letter, and a résumé, all demonstrating an

I really like to be contacted by letter (nonelectronic). No one does it anymore, but I love getting letters.

—Richard Smith, Senior Designer, The Pentland Centre, London, UK

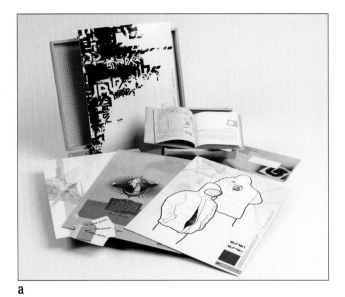

a

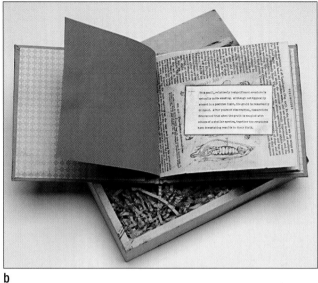

b

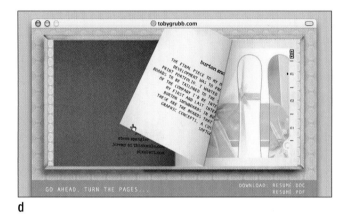

c

d

Figure 8-1a to 8-1d This portfolio demonstrates a flair for dramatic and effective branding. The wooden boxes used for the plate portfolio and the mail-in booklet are made to look like they were well-traveled, bearing stenciled markings, smudges, and partly torn labels. The patterned box liner matches the end papers of the portfolio book. The colors and materials carry through seamlessly into the packaging for the book, the binding, the business cards, and the Website.
Toby Grubb, Bradley University, Peoria, IL

awareness of typography and a clear hierarchy of information, all conforming to a cohesive branded style. Along with these items, a beautifully bound, hand-crafted booklet reveals pages that nestle into a classic grid format with tightly cropped examples of graphic design projects, and it culminates by directing the viewer to a Website to see more. If executed well, this résumé "experience" can stand out against the masses of daily mail and can often provoke an immediate response. Such a presentation combines two desirable qualities: good design sense and initiative. Figure 8-2, Kristen Ley's résumé package that arrives in a transparent sealed plastic sleeve, bound with a gold ribbon sliding band, the ends of which are held in place with sealing wax embossed with the letter "K," is literally an invitation to "Fall in love . . . with design."

We have seen many portfolio packages unified by means of graphic qualities: a combination of typeface selection, color palette, use of space or texture or material. All the pieces of the résumé package by Nick

I ignore emails and calls because, sadly, the industry is too fast and busy to answer all of the interested folks who use those means. Sometimes a good old-fashioned, stand out from the clutter, mail piece or viral site will make me appreciate the thinking behind a great idea.

—Bernardo Gomez, Creative Director, Euro RSCG, Chicago, IL

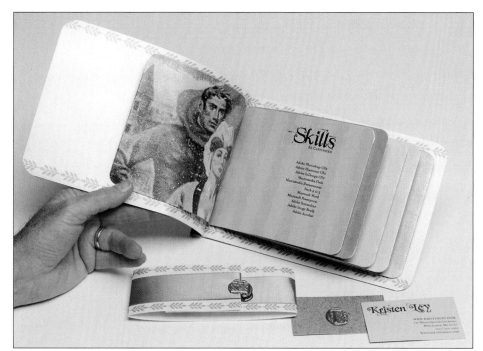

Figure 8-2 This résumé package conjures associations of nostalgia and romantic fantasy using subtle pastel metallic papers. Pages are titled: education, skills, awards, experience, activities, and references. Each page is larger than the one preceding it, creating an effectively tabbed margin. On the last page of the booklet is a DVD with samples of work.
Kristen Ley, Mississippi State University, Starkville, MS

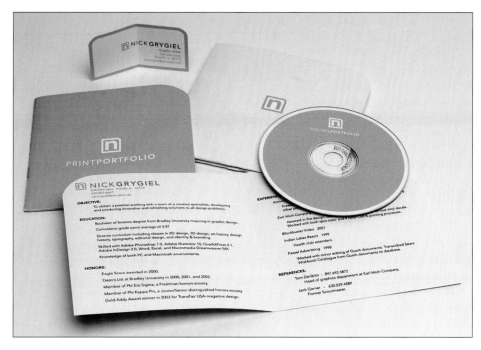

Figure 8-3 A strong brand identity, including bold color palette, are present throughout this résumé package. The logo appears on all pieces with the single curved corner theme integrated into the format. Materials consist of a branded mailing envelope, an outer container made of card stock, a cover letter, a double page spread résumé, a minibooklet showing examples of work, a business card, and a CD with more examples of printed work and multimedia projects. Overall size 5" × 5".
Nick Grygiel, Bradley University, Peoria, IL

Grygiel (Figure 8-3)—business card, cover letter, résumé, CD and outer casing—all appear as a unified set of branded literature. Grygiel actually created several different résumé packages—each one individually tailored to the specific company or position he was applying for.

A simple test of the effectiveness of an identity system is to distribute the contents of your application package on a cluttered table among other similar objects. If you can easily discern your items from the rest, then the system is, in one essential way, working correctly.

The Cover Letter

Whenever possible, the cover letter, résumé, and occasionally even the portfolio itself should be tailored specifically to each company or job title you are applying for. Any preinterview homework you carry out on the company, their clients, or any key individuals will make you shine in comparison to the other applicants. Start by identifying the name of the person you would most like to receive your résumé package (unless they request that you apply directly to Human Resources). Ideally, your

letter should be kept to about two paragraphs. It's an introduction to you, not your life story. Avoid repeating information already in your résumé, although one or two relevant key highlights of your education or career to date might be effective in identifying some of your strengths. The most important questions you need to answer in a cover letter are, "Why should they give you an interview?" and "What qualities do you have to offer their company?"

Everyone likes to receive compliments. Identify some positive events, accounts, campaigns, individuals, and awards, etc. that have impressed you about the company. In turn, this should help identify the reason(s) you would like to be part of their team. Don't go overboard with humor. Humor can be very individual and can easily backfire. Don't rule it out though, especially if your background check on a specific company indicates that they thrive on "fun."

When it comes to the body of the letter, consider type choice carefully. Obviously, readability is the priority. Although sans serif can be used for body copy, it can be tiring on the eye if there is too much text to read. Don't use a typeface that's too small or too fussy—no type below 8 point. You don't need more than two typefaces, perhaps even just one if you choose a typeface with a versatile font family. Remember that any type selection should ideally have a presence throughout your entire brand identity. It would make sense to use the same typeface for your résumé that you use for your correspondence. Choices of paper color, texture, and weight may depend on your design. As with typefaces, paper choice is an extension of your overall brand. Finally, check and recheck your cover letter for grammatical and spelling errors. Don't rely on the computer's spell-checker program. Proof everything yourself and also have someone else look it over.

The Résumé

You will almost certainly need not one but several versions of your résumé. These include a standard letter-sized résumé, a PDF of your résumé and an HTML résumé. Each of these can, in varying amounts, reflect some elements of your brand identity.

Résumé contents. The résumé lists the facts of your career, education, and abilities. Most professional résumés should be kept to one page. The exceptions to this are résumés for academic positions or grants, which usually go into more detail. List items in reverse chronological order. Put your most relevant strengths and achievements first, where they are more likely to be read. Focus on any roles or duties that support your objectives, and leave out irrelevant personal information. For employment, include the dates worked. If it is a design-related job, you can list the type of work and the clients. Use short sentences or phrases rather than long paragraphs. In list items, use parallel grammatical structure and be consistent with punctuation. Use action words such as *developed, presented, managed, coordinated*, etc. since these are words that will catch the reader's eye, especially if they are also key words they have included in any job description. Résumés are usually read quickly, so make sure you only include information that highlights your accomplishments.

List specific skills and software used. Interactive media companies, in particular, are often looking for people with very specific experiences. One suggestion is to organize your list of skills from general to specific. For example, start with listing general areas of expertise (Web development, user interface design, project management) and then list specific applications (Flash, ActionScript, PHP, CSS).

Many students initially feel that they do not have sufficient content for their résumé. There are many things that you have probably done that will be of interest to an employer: attending conferences, special training, one-day workshops, or volunteering in the community. Include any membership and involvement with design organizations, such as the A.F.G.A. Your school's career center can be of some help here, but they may not be aware of opportunities specific to the design field. As with all the text within your résumé package, check the grammar, spelling, and punctuation. Check it several times, and have someone else check it for you. Do not feel that a lengthy résumé is an advantage for most applications. Busy design studies will appreciate brevity.

The standard letter format résumé. Every applicant needs a standard letter-sized résumé that can be printed or converted to a PDF file. This standard résumé should not be confused with the résumé package as described below that can serve as a teaser or leave-behind. This is a piece of business communication and,

like standard business attire, shows a certain amount of respect. But also like business attire, it can look drab or it can look like a million bucks!

If you are a graphic designer, your résumé is potentially the most important piece of typographic design in your portfolio package. To the experienced designer, how you address the fundamental design issues in a résumé speak volumes about your training and understanding of typography. The function of a résumé is to convey factual information as clearly as possible. This is an exercise in restraint. Some of the most effective résumés are type-only, using one font, and making use of the elements of typographic syntax to convey the structure of the information contained within.

We gave fifty résumés prepared by graduating seniors to designer David Smit, who, in the course of his work, reviews many résumés. We asked him to select four of the best, each one exemplary for different reasons. His selections (Figure 8-4 a–d), are accompanied by his comments. A designer with many years of experience, Smit states emphatically that he can tell with a quick glance at the typographic design alone whether the individual is a trained and discerning designer or not.

A résumé involves making a hierarchical list, differentiating classes of information. The main topics should be easy to identify without calling more attention than they need. For example, if the body text is regular weight, the subheads don't need to be bold and caps and a larger font size and have a bullet beside them. Although it should not be overly decorative, your résumé can still retain elements of your brand identity, even if it is simply using your chosen fonts or color palette to connect the résumé with the other promotional materials. For a graphic designer, the résumé serves as a demonstration of how well you have mastered the subtleties of type design.

The PDF résumé. Export your résumé from your page layout program as a print-quality PDF, and put a link on your Website so a user can download a copy of your résumé as it is formatted for print.

The html résumé. There should be an html version of your résumé displayed on your Website. Even if you created your Website in Flash, it is still advisable to have a discreet link to an html page. The html version allows it to be scanned by search engines, and also allows it to be viewed without the hassle of downloading a PDF. If the above paragraph about the typographic design of your résumé sounded a lot like CSS, it is because the idea of imposing a semantic hierarchy on your information is a perfect model for the best use of Cascading Style Sheets. Your résumé logically breaks into "divs" or divisions, and within a single line you may have several style classes (place of employment, dates, duties). The html version may be less verbose and more telegraphic in syntax than your print version

since people are less inclined to read long sentences on the screen. Note that type sizes and formatting options that look great in print do not necessarily look good in the Web, so do not feel you have to duplicate the exact design on screen as you have in print. Joel Raabe's Website provides a well-structured, readable résumé (Figure 8-5, on page 96) while also providing a link to a printer-friendly PDF version.

With the emphasis on getting your name out there ahead of the crowd, it is understandable that many graphic design students are dropping the paper résumé in favor of an entirely online presence. Many companies now request this to be the first point of contact. Meg Pucino, who screens applicants at VSA Partners in Chicago, says, "I need to see something before anyone gets in the door. I ask for PDFs or links to work." Nevertheless, the argument for a printed-paper résumé "experience" can be equally convincing and has its advocates.

The Teaser or Leave Behind

One of the items in your résumé package that shows a few selected examples of your design work is often referred to as "leave behind." However this unique demonstration of your graphic design ability can successfully serve as both a preinterview teaser and a postinterview leave behind. As a teaser, its purpose is to give the recipients enough of an indication about your creative ability so that they ultimately want to call you in for an interview and to review your main portfolio. How you design this influential component of your self-promotional materials very much depends on your overall brand identity and résumé package concept as it may well incorporate both the cover letter and résumé within its pages or folds. It also has the capability to be so much more than just a vehicle for your work examples. If designed well, it can give the recipient a real sense of who you are by conveying personal thoughts and insights.

Personal narratives such as those relayed in Kyle Everett's leave behind book entitled "Anecdotes" (Figure 8-6a–d) give insight into how he perceives working in a professional environment. He lists things learned through (sometimes painful) experiences, like keeping fingers back while cutting mat board, and gives an account of a typical caffeine-fueled daily routine. His short, humorous, and well-designed anecdotes reinforce the impression of a person who learns quickly, is passionate about what he does, and always looks at things in an intelligent and creative way, for example; "In a larger company there are not only more names to know, but more people worth knowing." The book is an extended résumé that lists his education, his work experience, and his sources of inspiration. Included within its spiral bound pages is a foldout, a timeline interpretation of his résumé, and a pocket containing representative samples of his work.

Figure 8-4a Résumé and Cover Letter

Amy Reiner Bradley, University, Peoria, IL

Comments: *"Great solution to print the cover letter on the back of the résumé. They always will remain together. Good typographical hierarchy. Red accent adds warmth without overpowering. Nice paper color/weight/texture"*—Dave Smit, Designer, Pudik Graphics, Peoria, IL

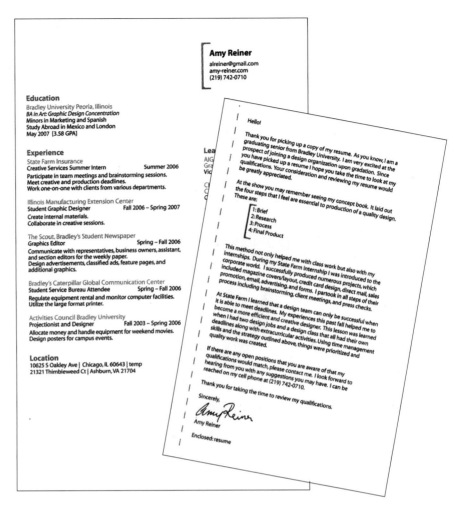

Figure 8-4b Résumé

Rebecca Lambert, Bradley University, Peoria, IL

Comments: *"Excellent use of negative space and clean and simple typography. Curve in the column adds the feminine quality and overall softness, countering the stiffness of the serif type. A quiet sense of sophistication accented with paper selection and color. It is a good design for a résumé without a lot of content."*—Dave Smit, Designer, Pudik Graphics, Peoria, IL

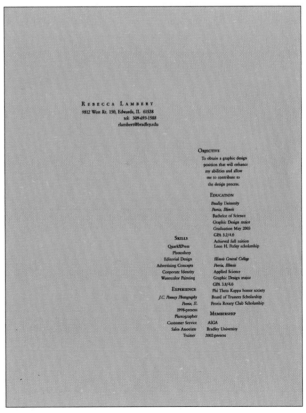

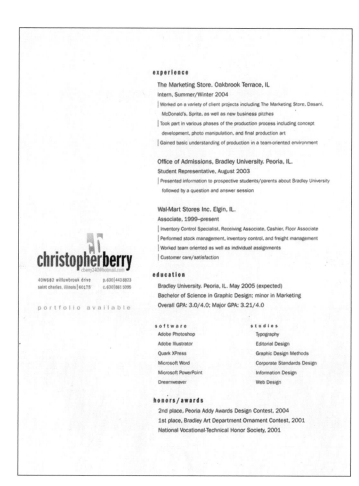

Figure 8-4c Résumé

Christopher Berry, Bradley University, Peoria, IL

Comments: *"Excellent color usage combing the warm grays and eggshell paper color gives a soft, inviting, friendly quality. Unique angle cut at the top adds that "masculine" touch without pounding you with Rockwell extrabold. Shows solid typographic skills and hierarchy. Orange accent is subtle and pleasant surprise. Overall, a very visually balanced design."*—Dave Smit, Designer, Pudik Graphics, Peoria, IL

MATTHEW TOLER :: WEB AND PRINT DESIGNER

401 EAST TAYLOR STREET, DEKALB, ILLINOIS | 217.369.5563 (cell) | 815.753.6067 (daytime) | mtoler@somethingburning.us | www.somethingburning.us/portfolio

2001	2002	2003	2004	2005	2006	2007

Timeline entries:
- Y&R CHICAGO, INTERN, DESIGNER (2006)
- NIU, GRAPHIC DESIGNER (2006–2007)
- NORTHERN ILLINOIS UNIVERSITY, COMPUTER LAB MANAGER (2005)
- HORIZON HOBBY DISTRIBUTORS, WEB CONTENT MANAGER (2001–2003)
- FREELANCE WEB CONSULTANT (2004)
- FREELANCE GRAPHIC DESIGNER (2005–2006)
- GRADUATED, UNIVERSITY OF ILLINOIS—BFA IN PAINTING (2001)
- ENROLLED, NORTHERN ILLINOIS UNIVERSITY—VISUAL COMMUNICATIONS (2005–2006)
- GRADUATED, NIU (2007)

DESIGN EXPERIENCE

High-level conceptualization of web and print projects, including client and press representative interaction, and multi-stage proofing process.

Production of finalized web and print projects, using industry standard software and up-to-date web technologies.

Print projects include identity, brochure, book/catalog and specialized materials, all produced within client's specified needs and budget.

Web projects include small, static page sites to establish web presence as well as large database-driven sites with heavy content updates. Larger projects have included hiring and supervision of database programmers.

Created enhanced web interfaces using Flash and Actionscript.

Worked within establish branding and design guidelines as well as using design expertise to establish new and original design standards.

TECHNICAL EXPERIENCE

PHOTOSHOP	HTML
ILLUSTRATOR	XML
INDESIGN	CSS
QUARK	ACTIONSCRIPT
DREAMWEAVER	
FLASH	
PAINTER	
FIREWORKS	

AWARDS AND RECOGNITION

2006 Chicago Book Clinic Scholarship Northern Illinois University Dean's List, 2004, 2005, 2006

REFERENCES AVAILABLE UPON REQUEST

Figure 8-4d Résumé

Matthew Toler, Northern Illinois University, DeKalb, IL

Comments: *"Unique size and orientation without being cumbersome. Timeline approach very personal and gives quick 6-year overview. Caught my attention as being unique and different. A little light on information but may elicit a follow up for more information."*—Dave Smit, Designer, Pudik Graphics, Peoria, IL

Figure 8-5 HTML résumé showing good typographical hierarchy.

Joel Raabe, Bradley University, Peoria, IL

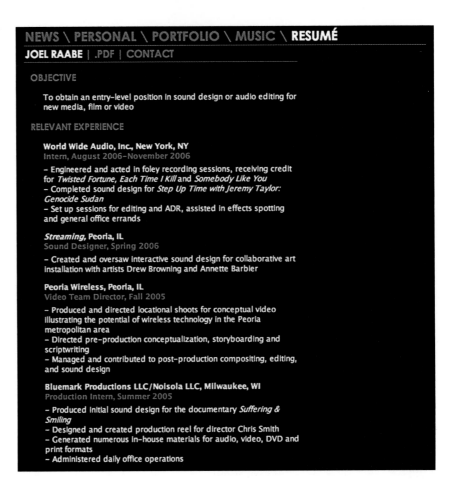

Employers are interested in your design skills, but they are also interested in you as a person and as a potential colleague. Keep in mind that this is also an opportunity to show something that may be of benefit to the employer, so what qualities you reveal about yourself should ultimately have a payoff professionally; for example, diligence, craftsmanship, or humor. The teaser/leave behind can serve as a springboard for discussion in an interview. If carefully considered, it may even double up as the container or "holding device" for all the other components of your résumé package. Figures 8-7 to 8-11 demonstrate a good variety of compact, easy-to-mail formats.

How you ultimately "package" all the components together depends on your overall design concept. Whether simply a functional envelope, or something more elaborate, your final résumé package needs to follow United States Postal Service guidelines if it goes through the mail. It must have packaging that can withstand being mailed. Consider the mailer itself as part of the design. If it arrives in a plain envelope, it may get ignored, or worse, they will think you neglected to design the outside, so be sure to continue your brand identity onto the outside label. One final word of note regarding the design concept for all your self-promotional materials: Remember that each time you apply for a job, you will need to remake/reassemble all the pieces. So make sure that your solution is fairly easy to replicate, since you will invariably need to make multiples of it. Avoid solutions where the ratio of effort or material is disproportionate to the effect.

And So Your Adventure Begins

You and your portfolio are starting on an adventure. Although it may seem that a lot of people have been telling you what you should do and what is important, perhaps it is good once in a while to reflect on the fact that YOU are important. When you walk in with your portfolio, it may seem that all the power is on the other side of the table, but remember that you have something they need, too. It can be a fresh attitude, it can be energy, and it can be new perspectives on old ideas. As Bernardo Gomez, Creative Director of Euro RSCG, reminds us all, "I don't expect someone out of school to know everything. I just want to be blown away with fresh ideas."

It is almost expected that graduates of most four-year design curricula will possess most of the basic skills with the technological tools of the trade and the common problem-solving methodologies. What is really at a premium, though, are people who can connect what

(continued on page 99)

a

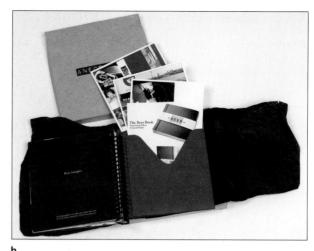
b

c

d

Figure 8-6a to 8-6d Presented within a handmade cardstock box and wrapped in black tissue paper, this compact (5" × 5") spiral-bound résumé book titled "Anecdotes," contains pearls of wisdom based on past experiences and accumulated knowledge. Abstract photographs on the opposite pages complement the well-crafted copywriting, and acknowledged song lyrics reinforce the overall tone of voice throughout the booklet. The résumé is presented on vellum as a fold-out horizontal timeline. A CD/DVD attached to the inside back cover contains examples of work. (This particular piece was a *HOW* magazine overall student award winner in the Self-Promotion issue.)
Kyle Everett, Bradley University, Peoria, IL

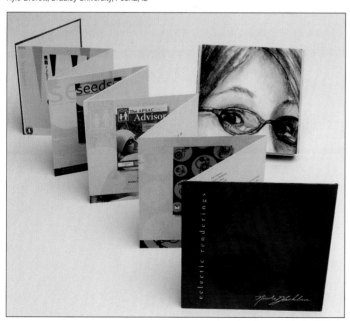

Figure 8-7 A hand-written signature and special focus on drawing skills provides a brand connection throughout this résumé package (5" × 5"). The Japanese fold stylebook contains five spreads on the front and four on the back, displaying relevant résumé information and a complementary mix of process sketches and finished pieces. The book is held shut with a cardstock slip band that matches the outer casing imagery.
Nicole Blackburn, Bradley University, Peoria, IL

Figure 8-8 This hand-made green leave-behind box, 5.5" × 7.5" × .875" contains an accordion fold insert with 9 panels that extends to a total of 54", printed on one side, each panel displays an image from a project, and one panel contains name, address, Website and email. The green color continues throughout all the components of the portfolio package.

Lindsay Landis, Art Center College of Design, Pasadena, CA

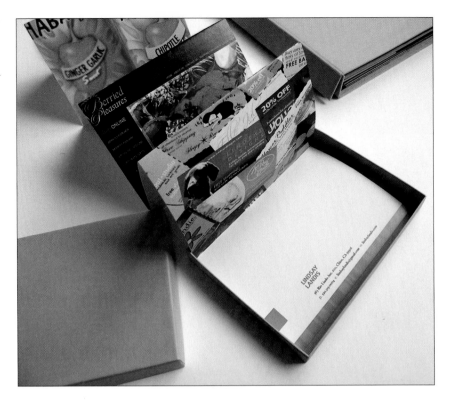

Figure 8-9 The outer envelope, on a recycled stock, folds down to 4" × 6" and holds a business card. Seven double-sided cards each display the résumé information on one side, e.g., work experience, education, etc., and a cropped sample of graphic design projects on the other side. "I wanted something clean and simple, that expressed my design aesthetic, and was easy to make changes/additions to. I also wanted it to be eye catching."

Jennifer Oster, Bradley University, Peoria, IL

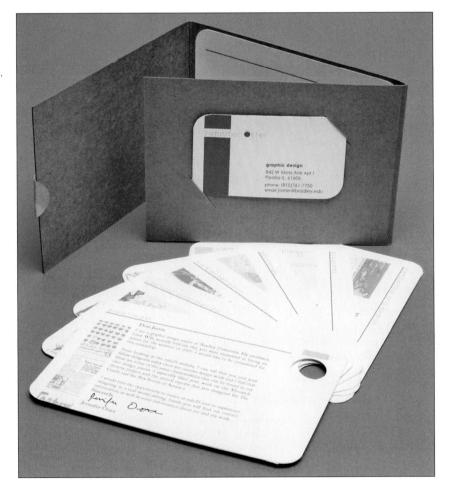

Figure 8-10 This complete portfolio package is distinguished by color and pattern. A set of self-promotional cards with samples of her work introduce the brand identity. The color recurs on the pages of the portfolio book as well as her résumé.

Catherine Oshiro, Art Center College of Design, Pasadena, CA

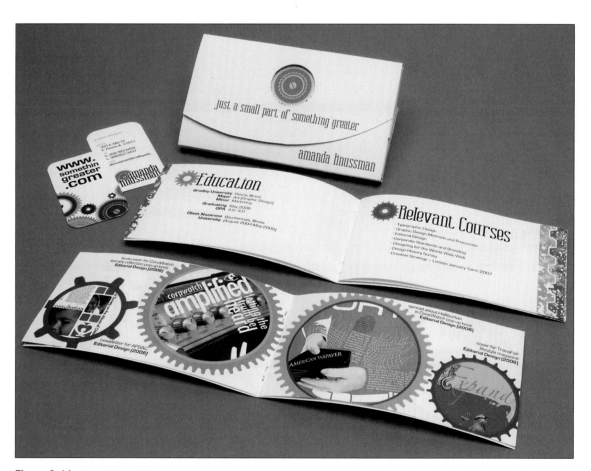

Figure 8-11 Powerful graphics and a personal word mark collectively make this résumé package stand out. The tagline about being "a small part of something greater" stemmed from Knussman's realization that "I am just one person, who needs other people to succeed, yet unique in my own right. This concept developed into the illustrations of the gears." Overall size 7" × 4". The package consists of two books, one containing résumé information and the other presenting samples of work.

Amanda Knussman, Bradley University, Peoria, IL.

Be fearless . . . everyone who is practicing passed through the interview process before; they have all been there and want to meet someone new who is rising to the occasion.

—Rick Valicenti, Principal, 3ST, Chicago, IL

they know about design to other disciplines—who are globally conscious and able see connections between ideas and solutions across a diverse range of disciplines. In demand are those who do not unnecessarily restrict their thinking, but show curiosity and passion for a multitude of ideas. Design thinking is about solving problems in creative ways, and that can have truly global effects.

So don't apologize for what you do not know; instead be proud of what you do know and are capable of. Always remain curious, and approach every situation with a sense of adventure, for that is what it truly is.

Appendix: Design Office Survey

Professor Petrula Vrontikis conducted this survey recently for clarification of lecture material in her Portfolio and Career Preparation class for graduating seniors at Art Center College of Design in Pasadena, California. Seventeen top U.S. graphic design office principals answered questions about the job inquiry process for recent graduates:

1. Do you prefer that a recent grad, looking for an entry-level position, send you a cover letter and resume by email or regular mail?

5	Email
8	Regular mail
4	Both OK

Comments:

"Both, but I tend to keep good 'printed,' resume packages."

"I actually kind of like snail mail—it's a more permanent record, and, for some reason, it always helps me evaluate the sensibility of the candidate."

"Cover letter only by email works best for me."

"A real letter always beats anonymous email."

". . . send an email and follow up with a snail mail—especially if there is something nice about the paper, that it's letterpressed, etc. And especially if they are applying for a print position. I would reference in the cover letter that they already sent an email."

"I prefer regular mail in a unique and sophisticated presentation."

2. Do you prefer that they follow up by email or by phone?

12	Email
2	Phone
1	Either
2	Both

Comments:

"Both. They should be persistent if they are serious!"

"Either way. It would be refreshing to actually have someone follow up. So many say they will but don't."

"Definitely email. I have the hardest time returning phone calls, and oftentimes your voice mail message may get cut off or is unintelligible. Sometimes I've deleted messages by mistake. If you do have to leave a voice mail, please leave your phone number early on in the message, say it slowly, and repeat it. All in all, an email is much, much better, because all your information is more easily accessible, and more easily recovered."

3. If materials are sent by email, would you rather have a link to their Website, or a PDF attachment of 3–4 sample projects?

4	Website
4	PDF
9	Both OK

Comments:

"I am open to both; though I often find PDF work better for me—I end up printing them out to read."

"A PDF with 3–4 samples. If I like that, I'll want to click through to a site."

"Either one, as long as the site is fast and easy to navigate and gets right to the work, not too tricky!"

"Both are fine as long as they're well-structured. That means a manageable file size, fast load time, and an easy path to your work that's easy to see. A well-executed Website tends to show more of your capabilities than a quick PDF, but I've seen really nice examples of both."

"In the old days, I asked for a letter in the mail, but lately we've compromised and do receive letters email. The staff here looks at the portfolios if they are attached, which is no big deal, and looking at a PDF of three or four samples is okay. Looking at a Website is also fine with me."

4. If there's an attachment, what's the maximum size you think appropriate (in MBs)?

10	Under 2
3	Under 5
2	Under 10

Comments:

"I just hope they open up."

"Small— maybe 6-8 pages with separate file for the cover letter and resume."

"At times we receive eps attachments of more than 5MB, and this proves very challenging."

5. If it's sent by email, and they have a letter of recommendation, is it OK to send a copy of the recommendation letter as an attachment?

10	Yes
3	No

Comments:

"I would want to see the letter of recommendation when I review the actual portfolio in person. Keep a copy with their resume."

"I'm fine with digital letters of recommendation—I actually don't place much emphasis or credence on them (whoever solicits a bad letter of recommendation). If it's from someone I know—Beirut, the VSA boys, et al—I may pay more attention, and I would likely pick up the phone and get a verbal recommendation if I'm liking the candidate."

"I've never seen a letter of recommendation that I thought was impressive, to tell you the truth. The job history/education parts of the resume say enough."

"I don't need a letter of recommendation yet. I only look at those once I'm considering hiring the person. If they attach a recommendation, I perceive it as pushiness, insecurity, or name dropping."

"I suppose a letter of recommendation ought to be on a letterhead, when we receive one."

"A call of introduction from a colleague goes much further as well."

6. Would sending it as a scan or a PDF make you wonder if it's authentic?

3	Yes
6	No

Comments:

"No, I wouldn't question authenticity, as I would most likely follow up and call the person who wrote the letter."

"Sure. Send what you like. In this day and age, I wonder about the authenticity of anything and everything. I can show you a letter by Queen Elizabeth telling you that I'm her favorite graphic designer of all time and that I brew a mean cup of tea, too. Just give me a few minutes. That said, receiving letters of recommendation from anybody is a fairly rare thing, so you should expect that I'd get in touch with the person recommending you. So if there's any funny business, I'll find out and then I'll come hunt you down."

"I think we're adjusting to the convention of using email as a method of transferring data. It becomes more important for employers to check the references."

7. If you are writing a letter of recommendation, would it be OK with you if the person requested it in digital form?

13	Yes
0	No

Comments:

"Yeah, sure. I'd have no problem with that, because I'd only write a letter for somebody who had earned my trust. Honestly, I'd probably offer to write a letter directly to the person they're trying to reach. That carries a lot more weight."

"I personally try to mail my letters of recommendation on [my studio's] letterhead, however I'll fill 'em out online if I have to."

8. How many job inquiries from recent grads do you receive in a month?

5	0–5
3	6–12
1	13–20
2	21–30
3	31+

Comment:

"This spring, up to 100 or more, so we have a process."

9. How many of these recent grads received an actual portfolio review with you or one of your staff over this year?

10	0–5
5	6–12
1	13–20
2	20+

Comment:

"Few, because most did not follow up."

10. How many entry-level designers have you hired this year, either freelance or full-time?

12	0–5
0	6–12
0	13–20
0	20+

Comments:

"None this year; all designers here started as entry level, one has been here 10 yrs and two others over 4 yrs."

"Three, but we don't hire any entry-level designers directly out of school; instead, we offer them internships."

Responses from:
AdamsMorioka
Robert Louey Design
LAD Design
FIDM
KBDA
The Garza Group
344 Design

Stone Yamashita Partners
PhD
Geyrhalter Design
LOOKING
Chen Design
Visual Asylum
Pentagram (NY)
Hatch Show Print
Grant Design Collaborative
Willoughby Design Group
Roadf

Participating Institutions

Academy of Art University, San Francisco, California

Art Center College, Pasadena, California

Bradley University, Peoria, Illinois

Carnegie Mellon University, Pittsburgh, Pennsylvania

Cranbrook Academy of Art, Bloomfield Hills, Michigan

East Carolina University, Greenville, North Carolina

Florida Community College, Jacksonville, Florida

George Mason University, Fairfax, Virginia

Mississippi State University, Starkville, Mississippi

Northern Illinois University, DeKalb, Illinois

The Portfolio School, Atlanta, Georgia

Pratt Institute, Brooklyn, New York

Ringling College of Art and Design, Sarasota, Florida

Tidewater Community College, Norfolk, Virginia

University of Cincinnati, Cincinnati, Ohio

University of Georgia, Athens, Georgia

University of Illinois, Champaign-Urbana, Illinois

University of Minnesota, Duluth, Minnesota

University of Southern California, Los Angeles, California

University of Texas, Austin, Texas

Washington University, St. Louis, Missouri

Yale University, New Haven, Connecticut

Bibliography

Baron, Cynthia. *Designing a Digital Portfolio*. Berkeley, CA: New Riders Publishing, 2004.

Bedno, Edward. A Program for Developing Visual Symbols, *Visible Language*, Vol. 1–4. Cleveland, OH: Cleveland Museum of Art, 1972.

Clark, Sheree L., and Kristin Lennert. *Get Noticed: Self Promotion for Creative Professionals*. Cincinnati, OH: North Light Books, 2000.

Crawford, Tad, ed. *AIGA Professional Practices in Graphic Design*. New York, NY: Allworth Press, 2008.

Elam, Kimberly. *The Grid System*. Princeton, NJ: Princeton Architectural Press, 2004.

Endsley, Mica R., Debra G. Jones, and Betty Bolte. *Designing for Situation Awareness: An Approach to User-Centered Design*. London, UK: Taylor and Francis, 2007.

Fletcher, Alan. *The Art of Looking Sideways*. New York, NY: Phaidon Press, 2001.

Gordon, Bob. *Making Digital Type Look Good*. New York, NY: Watson Guptil, 2001.

Grannell, Craig. *Web Designer's Reference*. Berkeley, CA: Apress, 2005.

Heller, Steve, and David Womack. *Becoming a Digital Designer*. Hoboken, NJ: John Wiley and Sons, Inc., 2008.

Hurlburt, Allen. *Layout: The Design of the Printed Page*. New York, NY: Watson Guptil, 1977.

Landa, Robin. *Designing Brand Experience: Creating Powerful Integrated Brand Solutions*. Florence, KY: CENGAGE Delmar Learning, 2005.

Linton, Harold. *Portfolio Design Third Edition*. New York, NY: W.W. Norton and Company, 2004.

Linton, Harold. *Marketing for Architects and Designers*. New York, NY: W. W. Norton and Company, 2005.

Meyers, Debbie. *Graphic Designer's Guide to Portfolio Design*. Hoboken, NJ: John Wiley and Sons, Inc., 2005.

Monahan, Tom. *The Do-It-Yourself Lobotomy: Open Your Mind to Greater Creative Thinking*. New York, NY: Wiley, 2002.

Parker, Roger C. *Looking Good in Print*. Scottsdale, AZ: Paraglyph Press, 2003.

Scher, Paula. *The Graphic Design Portfolio*. New York, NY: Watson Guptil, 1992

Smith, Keith, A. *Exposed Spine Sewing*. Rochester, NY: Keith A. Smith Books, 1997.

Smith, Keith A., and Fred Jordan. *Book Binding for Book Artists*. Rochester, NY: 1998.

Tidwell, Jennifer. *Designing User Interfaces: Patterns for Effective Interaction Design*. Berkeley, CA: O'Reilly, 2005.

Walton, Roger, ed. *Designers' Self Promotion: How Designers and Design Companies Attract Attention to Themselves*. New York, NY: HBI, 2002

Zeldman, Jeffrey. *Designing with Web Standards*. Berkeley, CA: New Riders Publishing, 2007.

Index